Photo Retouching
with Adobe®
Photoshop®

Second Edition

Gwen Lute

AMHERST MEDIA, INC. ■ BUFFALO, NY

Published by:
Amherst Media, Inc.
P.O. Box 586
Buffalo, N.Y. 14226
Fax: 716-874-4508
www.AmherstMedia.com

Publisher: Craig Alesse
Senior Editor/Production Manager: Michelle Perkins
Assistant Editor: Barbara A. Lynch-Johnt

ISBN: 1-58428-080-8
Library of Congress Control Number: 2001133138

Printed in Korea.
10 9 8 7 6 5 4 3 2 1

Table of Contents

Acknowledgments

I want to extend special thanks to many people—however, if I listed everyone that has helped me on this project, I would run out of room to write their names down on paper!

Always First with me, I have to mention that I could not have the energy, enlightenment, and joy for living and teaching without the Light source of my soul, the Most High.

Then, my loving husband Ron, who read the drafts of this book at least thirty times since I started—and he doesn't even have an interest in Photoshop. What dedication and love!

Ivan Travnicek, who gave me the idea that I needed to write a book on retouching in the first place.

▷ **CONTRIBUTORS**

I would at least like to make mention of all the contributors of images to this book that do not mind me mentioning them. They are listed in the order their images appear in the book:

Garry N. Hulderman. The first project was a German Shepherd. They breed these beautiful animals in Riverside.

Craig Carter (of Countryside at the Cottage, in Riverside, CA). For the little fairy and the beautiful day lily shot. I also am grateful to Adele C. Fraziar for letting us use that shot of her daughter.

Lorrie Joseph (of Lorrie Photographer, in Riverside, CA). For the image of the two little girls, and the wedding portrait in the garden. I also would like to thank Judy Sharrow for giving permission on behalf of her two beautiful children.

Phillip Stewart Charis. We actually sat down together and did what I call "popping of the eyes" to bring out the features that are already there. For the technique I share in this book on the image of the little girls, I must thank Mr. Charis for his invaluable input.

June Nelson gave me permission to publish the photo of her when she fell on her face. She has since passed away, but I am grateful to her family for allowing me use the image. Thanks to Diane Shirota who took that image.

Tom Humphry (of Humphry's Portrait Design in Rancho Cucamonga). For the image of the Poodle, Buffie.

Bill Wilbur (of Classic Images in Rancho Cucamonga). For the beautiful outdoor portrait of the girl on which I demonstrate retouching with the Healing Brush. Jennifer Mitchell posed for that image, and I thank her for letting me use her portrait in this book.

Ladair Bergman is the beautiful bride in the garden, thanks again.

Little **Hana Sharrow** is the subject of the black & white image I sharpened in the book.

Sam D. Rose (of Blue Moon Photography in the Kansas City area) is my brother. His studio specializes in portraits of children from

newborn to five years old. I thank him for letting me experiment with the images of the two children on the wagon and the little angel. I also thank Mr. Phillip Fry for allowing me to use his gorgeous children in this book.

Charlen Taylor—thanks for letting me use the image of you in the feathers.

Grace Dahl owned the image of the bride and groom with shadows on the dress—thanks for letting me use that image!

Charlie Allen (of Charles Allen Photography in Pasadena). Thanks so much for letting me use those great images of Mount Rushmore. I really appreciate Charlie's diligence of explaining to me the way the digital world works for commercial photographers.

Rick Osteen. Thanks for that great shot of the beautiful Arabian horse.

Jerry Rose. Thanks for letting me use that great shot of Monument Valley. By the way, Jerry is my father and my inspiration. He gave me a Rolleiflex at age sixteen and helped create in me a passion for photography. He is also the Chief in the WW2 image with the sailors. I thank my mom, Georgia Rose, for hand tinting that small photo over fifty years ago.

David Earhart (of David Earhart Photography in San Bernadino). Thanks for all the interesting old photos you bring me to restore—especially the toddler smoking a cigarette, taken around the turn of the century.

Paul Boron Pam. Thanks for letting me restore that old wallet-size photo of your mom and grandma from Guatemala. I used it through out the book.

Cathy Moore. Thanks for the wonderful image of your mom in the field of flowers, and your idea to color just the flowers.

Christine McElhinney. Thanks for letting me use the image of your cat getting into your oils. I just love that image—and I appreciate you letting me use it for this book.

Mark Jordon (of Mark Jordon Photography in Orange County). Thank you so much for letting me use the image of the family that wanted the brother added in later. I really do appreciate the way you anticipated every problem and photographed the brother in the same light and setting. To the Goolsby Clan—I hope you don't mind me bringing your family together, but it was necessary for the portrait! Thanks for letting me use it in this book.

The last image in the book is a photo taken by my dad, Jerry Rose. I was holding the hand a small child. The message of this image clearly states my dream: "Uniting around the world." I created this after the 9/11 tragedy.

The story would not be complete without thanking the publisher, Craig, and my editor, Michelle, for working with me through the years and helping me grow. My contact with them would not have happened without Nick at Claremont Camera, who took me aside when I approached him with my first idea of a book. He took me over to the book rack, provided me with an example of the type of book I needed to develop, and gave me the name the publishing company I needed to contact: Amherst Media. That is how this all came about—thanks again, Nick!

Introduction

▷ THE ART OF RETOUCHING

In normal art forms, the work of art is produced from scratch—on a blank canvas or from a lump of clay. The retouching artist, on the other hand, begins with a completed but *flawed* product that needs repair. A good retoucher or restoration artist can complete a job so that the customer is unable to tell where corrections were made to the photograph. The final product should appear natural, with cracks that have simply disappeared, and missing areas of the image that have been seamlessly restored. It is a difficult and challenging task.

Professional photographers of all kinds seek out independent retouchers and restoration artists for assistance with their products. After all, the photographer's expertise is *photography*, not the art of repairing an image. People in portraits will need to have pimples, crow's feet, moles, scars, birthmarks, bruises, bald patches, glare and blemishes of all types removed. The retoucher may even be asked to move heads around, or to remove one or more individuals from a picture. It is the retoucher's job to help all of the individuals in a photograph look their best.

A first caveat: do not change the character of an individual or an animal without the permission of your customer. All professional photographs are copyrighted and the copyright privilege normally belongs to the photographer. The copyright privilege will seldom, if ever, belong to the retoucher—no matter how much work goes into repairing the image. The retoucher should obtain the permission of the photographer *before* making any changes to a professional photograph. When contracting for restoration or retouching work, the photographer will usually provide the retoucher with a complete list of retouching instructions, and sometimes a proof-print with instructions marked on it.

The morality of retouching becomes tenuous when dealing with real events. A retoucher must be careful not to be drawn into illegal activity, such as manipulating a picture for a court case or an insurance settlement. For example, if a picture of an automobile accident is presented for retouching, don't move the wrecked cars around. If you, as a retoucher, are unwittingly duped, you won't be held liable; but it is best to stay on guard and not be drawn into a collusive activity.

By adhering to these simple precautions, you can experience the joys of restoring images without worry. Retouching and restoration is fun. If you learn the basic retouching techniques you can open the door to making good money, while discovering yourself and enjoying your work tasks immensely. This book is designed to show you how.

▷ A HISTORICAL PERSPECTIVE

The art of photography began in the 1800s with black & white photography. Along with photographs came the need to alter or remove blemishes in the images. In the beginning, portrait retouchers used a long, sharpened shaft of graphite to retouch a negative. This process continued for many decades. The etching knife was soon discovered as a useful adjunctive tool for creating eyelashes and adding other dark aspects to the photographs.

While retouching was introduced shortly after the beginning of photography, it took the glamour girls of Hollywood, in the 1920s and 1930s, to bring beauty to a high form of illusion. Airbrush artists have been used since the early 1930s for retouching, and demand for this service has always been high. Airbrush artists have their own form of polished-looking art used in advertising, publishing, movie posters and men's magazines, where goddesses are created out of mortal flesh.

Hand-tinting soon became an art form as well, as individuals wanted color in their photographs. This process began with the use of dry powders on daguerreotype portraits, then made a transition to oil and watercolor paints with the debut of paper photographic processes. Color dyes have been readily used by photo retouchers to tint black & white photographs. The dyes are absorbed by the emulsion and become a natural and permanent part of the photograph. Transparent color oils were used as an alternate means of colorizing, as well.

With the advent of color film came the need for color retouching methods. Since their development, dyes have remained a primary retouching medium, and are applied with a brush. A newer product provides dyes in individual pens. Pastels have become popular, as

FOR EXAMPLE . . .

The photographer's camera falls apart during a wedding. The once-in-a-lifetime shots seem lost! The dark line or lines that result would normally spell disaster (and possible legal action against the poor photographer). But with the assistance of digital retouching, not so!

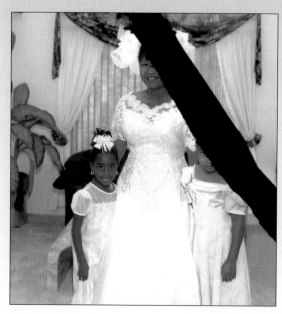 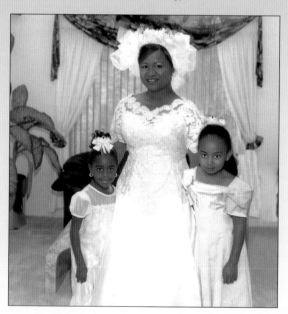

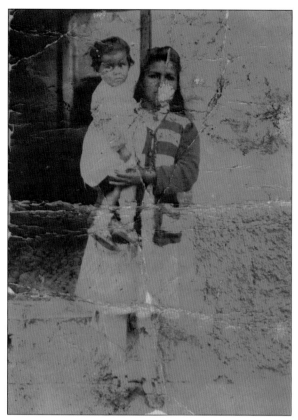

well. The important point for the retoucher is to choose the most appropriate method for a particular project.

Eventually, companies like Adobe® also developed programs that could be used to retouch photos digitally. There was much in the field that remained unknown, however, since most of the early texts and demonstrative software focused on using the new software for the creation of graphic arts, not for retouching. As a result, the advent of digital retouching did not mean that traditional methods became obsolete.

Soon, technically-oriented individuals purchased photo-retouching programs and attempted to compete in the retouching market by offering digital retouching as an alternative to traditional methods. While these practitioners were capable of following technically-correct processes, they often lacked the artistic skill and knowledge of the experienced retoucher. Seasoned retouching artists looked at digital programs and many had no desire to abandon their learned tools.

One of the first barriers to digital retouching was the need to learn a completely new language—bits, bytes, megabytes, gigabytes, gigaflops and terabytes, not to mention RAM and ROM, to name just a few. Additionally, all computers and equipment are not equal in value and usability. These barriers alone are enough to keep most retouchers from exploring the art of digital retouching.

▷ WHY USE DIGITAL RETOUCHING?

Long before I became involved with digital retouching, I worked as a retouching artist in my parent's color lab. I remember an instance where they were faced with a dilemma: our photographer had taken a series of family por-

traits of a group of six sisters. All looked beautiful in the best shot—except the youngest sister, who had her head hanging down with her eyes closed. The family did not like the portrait. The only picture available of her where she looked good was taken farther from the camera. Additionally, everyone else looked bad and her head was smaller than in the other image. All of the staff said it could not be corrected. I took it upon myself as a challenge, and went into the darkroom. Eight hours later (making many adjustments to the enlarger and using various complex printing techniques), I produced an acceptable portrait. Using digital retouching, I could now easily complete this same task in a few minutes. In fact, I receive many jobs like this from photographers.

Many projects that the modern photographer encounters can now be dealt with more easily and quickly using digital techniques. Additionally, some projects that are virtually impossible to correct with standard retouching techniques have now become possible through the use of computer retouching.

Old cracked or damaged photos that are a part of a family's treasure of ancestral records may be presented to you for restoration. In the past, it would have been almost impossible to accurately restore these photos to their original state. Now, with the assistance of digital retouching, such heirlooms can be completely restored by recapturing and reprinting them as new photographs.

When the customer desires multiple prints in various sizes, it used to be more effective to reproduce these from a negative, due to loss of quality when using digital files. This has recently changed. The resolution of high-end digital cameras now allows the user to produce images up to 30"x40"—and all the sizes in between. To obtain high quality results at this size, the camera camera must be capable of

ADVANTAGES OF DIGITAL

- Adding or subtracting objects or people
- Provide new and/or different backgrounds
- Arranging items in an image
- Replacing missing parts
- Colorizing
- Repair old, damaged and destroyed images
- Remove distractions

DISADVANTAGES OF DIGITAL

The primary disadvantage is the learning curve required by the software.

capturing a 6 megapixel (or higher) file. When scanning negatives, the end product will be of the highest quality if the scan ratio is accurately calculated from the beginning (this process is discussed in chapter 2). The end result will be a high-quality print, even at large sizes.

Digitally retouched images are high quality products—whether only the skin was retouched or a major alteration has been accomplished (i.e., installing a different or better head on a body). In the "bad old days" many of these operations were almost impossible to accomplish when manually retouching negatives and airbrushing prints. When they *were* done they often appeared to be unnatural.

▷ THE WAVE OF THE FUTURE

The future of the retouching industry lies in the area of digital retouching. Predictions by film producing companies is that film will become obsolete by the year 2010. While this may or may not happen, digital cameras are growing in popularity and availability, as the cost becomes more and more within reach of

the consumer. It is only reasonable to be prepared and trained for this eventuality.

▷ RETOUCHING SOFTWARE

Adobe® Photoshop® is the industry-standard imaging software for Macintosh, Windows and Windows NT computers. There are many other photo-retouching programs available at a lower price, but Adobe says it best in one of their advertisements: "Now you can do the impossible on a daily basis." The fact is, no other program can currently compare with Photoshop. In fact, many photo-retouching software producers consider their product to be adjunctive to Photoshop, because they are unable to directly compete with the quality and versatility of Photoshop.

The latest upgrades to Photoshop have provided necessary changes that offer the Photoshop user increased versatility and improved ease of use. Some key additions are:

Multiple Undos. Photoshop can track up to 99 operations, giving you the ability to backtrack one operation at a time, or—with a mouse click—revert to any earlier operational stage in order to complete corrections.

Multiple Filters. There are many filters available. Their basic purpose is to apply special effects to images. Not only are special filters available, but third-party filters can also be purchased and imported into the program.

Editable Vector-Based Type. Adding text to a photograph has required additional software programs in the past. Photoshop permits the creation of editable type. This type remains editable and vector-based as long as it remains in its own layer. Once the image is flattened, this process renders the type into pixels and the type becomes a bitmapped image.

Actions. When completing a repetitious series of tasks, the series of steps can be saved as automated functions and used repeatedly. The simple click of a button will produce the same action as often as it is needed.

Consistent Color Management. Photoshop is designed to maintain consistent color output when moving images to other systems. The bottom line is that color consistency is maintained from what is seen on screen to the output device.

Healing Brush. A new way to remove blemishes in a natural-looking way

▷ PLUG-INS

Plug-ins are processing programs that enable new features to run within Photoshop. A number of importing- and exporting-automation and special-effects plug-ins are included in the Photoshop program, allowing the user to increase the software's functionality.

PERSONAL EXPERIENCE

My own personal experience began the first time I loaded Photoshop onto a computer. At the time, we owned a Macintosh Performa 476 with a 256MB (megabyte) hard drive and 20MB of RAM. The color monitor was a 13" screen with a 256-color display. When I loaded version 2.5 of Photoshop into this computer, it crashed almost every time I attempted to use it. Looking at the large capacity of computers of the present day, it is not difficult to understand why: it lacked the power and memory to run Photoshop effectively.

▶ 1

Equipment

▷ EQUIPMENT: NECESSARY

The first step in digital retouching is to ensure that the proper equipment is available to you. As with any important task, if you do not begin with the right tools it can be a pretty frustrating process. Keep in mind that the industry is producing bigger and better models all the time. It is up to you to research the latest and most current technology prior to making an investment in any equipment. The following suggestions are based on my personal professional experience and are offered as suggestions.

The Computer. It does not matter whether you invest in a new computer or use the computer you already own—it may be a Macintosh, a Windows, or a Windows NT computer. The important thing is to be sure the computer meets the minimum power requirements. If you choose a Macintosh computer, it must be a Power Mac running OS 9.1 or later. If you use a Windows model, it must have a Pentium-class or faster processor, with Windows 98 (or later) or Windows NT 4.0 (or later).

RAM. With RAM (random access memory), more is better. How much RAM is really enough? While Adobe recommends a minimum of 192MB to run Photoshop, my personal experience suggests that even 250MB is only *adequate* (especially with large files, which will often end up crashing your computer). When working with images that are 16" x 20" or larger, 356MB (or more) is normally required. Expansion RAM units are readily accessible after the computer is purchased and, in most instances, are easily installed. For those who are uncomfortable with installing the memory units themselves, the computer can be purchased with additional memory already installed, or any service center will install the units for a minimal fee.

Hard Drive. Adobe suggests a minimum of 350MB (Mac) or 280MB (PC) of available hard disk space to run Photoshop. In practical terms, however, a minimum of 1G (gigabyte) of available internal hard drive space is recommended to install and run Photoshop effectively. Most computers are now being sold with multiple-gigabyte hard drives (often 25G and up), so such a model is not difficult to find. For best results, look for a model with at least a 10G internal hard disk to effectively run the program. Larger is better!

Speed. A Computer's speed is determined by its microprocessor. The faster the microprocessor operates, the less time it takes to progress from one phase of a task to the next. The best rule of thumb to follow is to purchase a computer with the fastest microprocessor available in your price range!

MEMORY

The important thing to do when purchasing a new computer is to shop for the best deal with the most memory (RAM) you can get. While closeout models can be obtained at a large discount, you may not want to sacrifice reliability and warranty coverage for cost savings. Sometimes, it pays to shop the local classified ads or to check out the Internet for used equipment. Wherever you find your computer, make certain it meets your software's minimum standards, and your needs for warranty coverage. The latest versions of Photoshop will not run without adequate power and memory!

Keyboards. Select a keyboard that feels good to you. It should feel comfortable when you are working, since you may be spending hours at a time sitting in front of it. There are a number of brands and prices ranging from about $30 to $200.

Mouse. Computers are normally sold with a mouse as standard equipment. If you must purchase a mouse, select a quality product that provides a smooth operation—or choose an alternate type of peripheral device (see Equipment: Optional).

CD-ROM Drive. Photoshop requires a CD-ROM to load, install and run the program. Most newer computers come with a CD-ROM (or CD-R) drive as part of the built-in equipment, but external models can also be used. If a CD-ROM is to be purchased, a recordable CD-R drive is a good investment, as it allows you to create CDs to store your completed images.

Monitor. While some computers come equipped with a monitor, they are usually 15" models. My recommendation is that you purchase a name-brand monitor that is at least 19", and capable of showing millions of colors. Select a model with a low monitor dot-pitch rating for better image resolution. For a 17" monitor, the dot pitch number should not be greater than 0.28. When shopping for a new monitor, it is best to consider a 20" or 21" monitor. These larger monitors allow the user to view the work being doing more clearly—and provide room for all the palettes to fit on the screen. It is important to keep in mind that the best monitors hold their color for only 3 to 5 years. They must then be replaced in order to ensure accurate color management.

▷ EQUIPMENT: SUGGESTED

Storage Devices. In addition to the internal hard drive in the computer, one or more portable storage devices is highly beneficial. Such devices provide a storage module that allows finished work to be recorded and transported or stored. It is important to be aware that availability of storage devices changes from month to month. Choosing a removable device that is widely used or preferred by your service bureau is the safest course of action.

Firewire hard drives are the best value around. These products are offered by a wide range of manufacturers and range from 60G to 120G—and even larger. The beauty of such a device is you can store huge amounts of data. Being affordable and reliable, these hard drives are presently the best solution for large image storage.

Iomega® products are also useful and are universally acceptable to service bureaus. The Iomega Zip® drive offers discs with both 100MB and 250MB of space, and is a reasonably inexpensive storage device. The Iomega Jaz® drive offers 2G storage discs.

Writing your images to CDs is an important solution and an increasingly popular option. CD- and/or DVD-recordable drives are now available as standard equipment in most Macintosh and Windows computers. You can do your backing up onto Firewire drives, then record the final images to CDs. Recordable CDs (CD-Rs) are inexpensive and highly portable, as they can be read by any standard CR-ROM drive. Keep in mind, however, that the CD-Rs you use must be of the highest quality. Cheap CD-Rs are not the best solution for any kind of longevity. I would recommend either Gold or Platinum CD-Rs.

Along with CD-ROMs, I find the new juke box produced by Power File® to be a very useful tool. Holding up to 200 CDs or DVDs, it is an affordable storage device that allows you to conveniently access thousands of images at one time.

External Hard Drives. External hard drives are a means of significantly expanding your storage and work space. Models range from about 10G to 180G (and higher). Different models also have various processing speeds. The greater the storage space and speed, the greater the cost of these devices, so it is important to find a size that meets your specific needs and budget. If your computer provides FireWire capability, a FireWire external hard drive is a very effective and efficient storage device that should be considered as a primary choice. Regardless of the type, using an external hard drive will free your internal hard drive space and make your work much easier. However, the external hard drive does not replace the need for a good removable storage drive.

Scanners. It is important to be aware from the beginning that a flatbed scanner is almost indispensible in completing the tasks described in this book. A color scanner converts printed images into digital files. Scanners use colored filters or a prism to read RGB (red-green-blue) intensities, and then combine these three single-color scans to provide a full-color image. These machines may take one to three passes to read the colors. They also vary in bit depth (the amount of color information they capture at each reading) and in resolution (how many readings per inch they process).

There are many scanner manufacturers. As in other fields in the computer industry, the technology is also changing rapidly. Before purchasing a scanner, it is important to review the latest computer magazines for articles that compare and rate the different models on the market. When considering a new scanner, the area to be most concerned with is the scanner's accuracy in reproducing colors and detail. The resolution (dpi [dots per inch) specifications of a scanner indicate the amount of data it captures, but not how accurate that data is. Image quality results can vary from one scanner to another—even though they may have the same ratings.

Optical resolution (as opposed to *interpolated* resolution) is the important figure to seek. The very minimum acceptable dpi rating for retouching is 800 x 1200 optical dpi. Most flatbed scanners now offer 2000 x 2400dpi or higher. Interpolated resolutions (the resolution often boasted by salespeople) will be higher, but less accurate. Base your decisions on optical dpi and bit depth. A bit depth of 3.4 or higher is a meaningful guide.

It is also important that the scanner be sealed. Older models were designed with air vents in order to provide ventilation. The problem is that these vents also allow dust to flow into the scanner. This dust ultimately shows up on the scanned images as dust spots, creating more work for the retoucher! A sealed scanner prevents this problem.

Graphics Tablet. Graphics tablets, digital tablet-and-pen peripherals that replace the mouse, allow greater freedom and versatility in the retouching process. It is best to try the various brands and sizes before purchasing one. The smaller sizes (e.g., a 4" x 5" tablet) is effective and more economical; however, the 6" x 9" size is more accurate and sensitive to your touch. My personal bias after using a number of brands is for the Wacom Tablet.

Trackball. Trackball technology is also rapidly changing. Basically, the trackball is a replacement device for the traditional mouse. The advantage of the trackball is that it allows the user to move the cursor with a stationary device in a limited space. It avoids typical frustrations associated with a mouse, such as running off the edge of the mouse pad. Models with a larger tracking ball generally offer more control of movement, but are also more expensive. Some models have additional button features that allow the user to customize utility functions.

PERSONAL CHOICE

While a graphics tablet is not a necessity, and a mouse or trackball can readily be used with Photoshop, I feel once you have learned to effectively use the tablet you will not want to use anything else.

Capturing the Digital Image

► THE DIFFERENCE IN COLOR

Black & white photographs are the simplest form of prints to work with because they require less memory. Color prints are more complicated, and the problems compounded. Working with color becomes simpler, however, when you understand the basic concepts of color theory, the processes, and how color prints differ from color transparencies.

A Color Primer. Traditional photographic prints are created with dyes and pigmented colors. In the traditional retouching process, dye is either directly applied or colors are mixed to produce the desired result. For example, if the desired color is green instead of yellow for the grass, a transparent wash of blue dye is added (because yellow and blue mixed together form green). If the existing color needs to be converted to black, a complementary color is used. For example, to correct the common photographic problem of red eye, a green dye would be used to turn the red to black. To correct transparencies, the same principle is used.

When a color picture is scanned into a computer to be retouched in Photoshop, the image can be retouched using either the RGB (red, green, blue) or CMYK (cyan, magenta, yellow and black) color mode. RGB takes up less image size space, and is normally the color mode required by color labs for photographic

print and film output. Most print shops, service bureaus and some color labs work with CMYK. If the final image output needs to be in CMYK, complete the desired corrections in the RGB mode, and save the finished product in its final version in the CMYK mode. Check with your service provider for the required mode before beginning the job.

► SCANNING TECHNIQUES

The first goal when beginning a retouching or restoration process is to get the original print into your computer at the final product's photographic-quality resolution of 300dpi. When scanning a photo that will be printed at a larger size than the original, if photographic quality is to be maintained, the resolution must be doubled for each doubling of the dimensions. For example, if a small image, say a 4" x 5", is to be retouched and printed out as an 8" x 10" photograph, it will need to

Left: Low resolution bitmap scan. Right: High resolution grayscale scan.

be scanned at 600ppi for it to come out as an 8" x 10" at 300dpi. If the desired size is a 16" x 20", the 4" x 5" would be scanned at 1200ppi.

Before scanning, wipe the photo with a soft, lint-free cloth. Also, clean the glass platen on your scanner—otherwise you will spend hours in Photoshop cleaning dust spots off the image, spots that could have easily been prevented. When the retouching or restoration process is completed and the picture is ready for processing, be sure to save it in the size the customer wants without upsizing the final image. If the image must be upsized, this must take place in the scanning, not in the final saving process. Check with the lab to be used for their requirements, and they will also help you eliminate other potential problems.

Remember, when working with original prints that are small but are to be printed at a larger size, they must be scanned at a high resolution so they can be reproduced at the larger size while maintaining quality. (For the highest quality work with an original image that is the same size as the image you plan to output and avoid scaling of any kind.)

The primary concern in scanning must always be achieving photographic quality at output. Often when a person invests in a flatbed scanner they think all of their problems are solved, but they may be wrong; there are occasions when scanning needs exceed the capabilities of any flatbed scanner. For example, a picture destined for use as a poster, billboard or negative will require a very high resolution and large output size. To obtain this type of high-quality scan, a drum scan is required. Unfortunately, drum scanners are priced at $8000 and up. This is where your friendly service bureau comes into the picture—the cost will be much more economical than attempting to purchase a drum scanner for personal use. When purchasing such a scan, is important to notify the service bureau of the desired resolution and the final image size, the type of computer being used, and the format the file is to be saved in.

Now that you have your image scanned and converted from a traditional to digital image, you are ready to begin retouching or restoring the picture.

GETTING STARTED

Before we begin the actual retouching work, let's review two basic selection principles:

1. When working with any selection tool, hold down the mouse button until the entire selection is outlined. If you release it before you return to the beginning point, the program will join the lines from the point where you stopped to the point where you began making the selection.

2. If you desire a soft edge on the selected area, use the Feather Radius setting. This is file-size and edge dependent, meaning that you use smaller Feather Radius sizes for smaller size files. However, the smaller the size settings, the harder the edges. Therefore, you may choose to use a larger number to provide a softer edge for better blending. When making a selection with any of the selection tools (i.e., the top three rows in your tool box) it is important to be aware that hard lines on the edge of the selection is a giveaway that the image has been altered—and the customer won't pay you for your work!

▶ 3

Restoring an Image

▶ IMPORTANT NOTE

From this point on I will use the designation "Command/Control" to signify the Macintosh Command key or the Windows Control key. Use the appropriate one for the platform you are using. The Macintosh Option and Windows Alt (Alternative) keys are synonymous in their use, not only in this book, but in most program manuals as well. Also, when you are asked to "click," this means you should press the button on your mouse, trackball, or tablet.

▶ USING LAYER MASKS

Our first project will involve removing an unwanted object from a picture. In this case, it is a person standing behind a show dog. The owner of the dog wanted to have this fine ani-

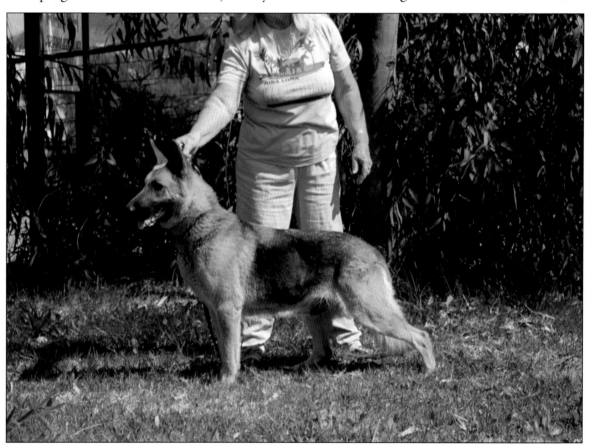

mal standing alone so she would be the center of interest in the picture, which was to be used in a professional dog breeder's magazine.

Once the picture is scanned, you can easily accomplish the retouching task using layers and layer masks. This will become clear if you want to experiment—or as you follow along with these steps:

Step 1

Open the picture in Photoshop. If the Layers palette is not already open on your screen, open it (Windows> Show Layers).

Step 2

In the Layers palette, duplicate the background layer by clicking and dragging the background layer onto the New Layer icon at the bottom of the palette.

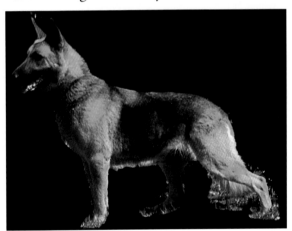

Step 3

Go to Filter>Extract (or use the shortcut: Command/Control + Opt/Alt + X).

Step 4

In the Extraction dialogue box, use the Highlighter tool to highlight the dog—going all the way around the dog and making sure the brush covers all the fur.

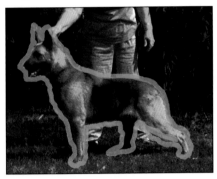

Then fill with the Paint Bucket to tell the program you want the entire dog selected, and click on Preview.

Step 5

Use the Cleanup tool to erase any part of the background that you want to remove.

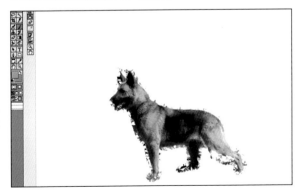

If you erase too much, hold down the Opt/Alt key to repaint. Make the transition smooth between the subject and background. Be sure to leave intact foliage around the dog (except in the area where the woman's blue jeans are).

Step 6

Click on the Lasso tool. In the Options bar, set the Feather Radius to 20 points (this number will vary depending on the size of your image). Select the desired area by click-dragging to the right of the eucalyptus tree trunk with the Lasso tool. The area being selected is defined by a dotted line.

Select the whole leafy area. Hold the mouse button down until the whole area is outlined. To finalize your selection, release the mouse button.

Step 7

Paste the selected area into a new layer (on top of itself) using a simple keyboard shortcut: Command/Control + J (to copy and

paste in one move). In the Layers palette, you will then see that there is a new layer—layer 1—that contains the area you just selected.

Step 8

Press the letter V or select the Move tool from the tool box. Then, drag layer 1 on top of the woman above the dog. Since this layer is sandwiched between the dog and the background layer, we only need to be concerned about bringing back the now-obscured tree trunk. Since the woman's arm and hand are in front of the tree trunk, we need create a layer mask to reveal the tree trunk. To do this, click on the Layer Mask icon at the bottom of the Layers palette.

The eucalyptus layer now has a white Mask next to the leaves in the layer.

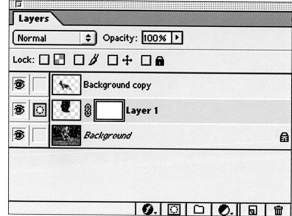

When you paint on the white Mask with black as your foreground color, that part becomes transparent (with the brush acting as an eraser). When you paint on the Mask with white as the Foreground Color, it reveals the layer. (Brush size can be changed by pressing the bracket keys.) It is important that the erasures are precise, which may require the image size to be increased by pressing Command/Control + the "+" key. This will double the zoom ratio each time you do it.

Step 9

Return to the background layer by clicking on it in the Layers palette, then select parts of the tree trunk with the Lasso tool. Press Command/Control + J to create a new layer,

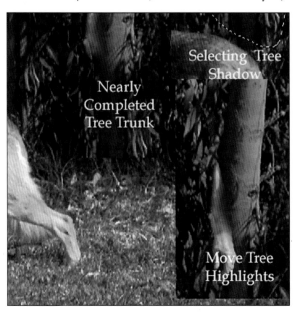

using the Move tool to align the new layers over the lady's arm, extending the tree trunk. In order for this to look right, you must choose parts of the trunk in the shadow under the arm. Duplicate layer after layer, repeating this action until the forearm and hand are completely covered with multiple layers made from selections. (*Caution:* Do not create obvious patterns in the area that you are layering.)

Step 10

You can now bring the various eucalyptus tree layers together to reduce the file size and more effectively manage your layers. First, click on layer 1. In the other related layers, the box between the layer thumbnail and the eye will be empty until you on it. A little chain will then appear in the box. Click on this box in each of the tree layers to link them together.

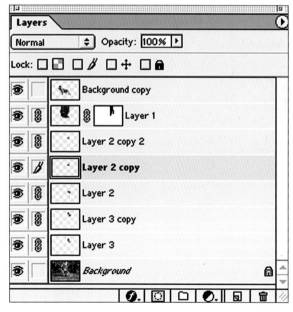

Next, click on the black triangle in the upper-right corner of the Layers palette to display a pop-up menu. Click on Merge Linked, and release. This will merge all of the tree layers together into one layer.

Step 11

In the Window menu, click on Show Navigator. At the bottom of this palette, you will see small triangles. You will notice when you move the slider in between them the image view becomes either larger or smaller.

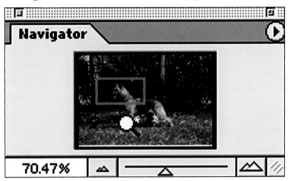

Move the slider toward the large triangles for an enlargement of approximately 150%. Now, when you place the cursor over the subject, it turns into a little white hand. In the Navigator, the red box shows the location of the screen image in relation to the total image. Move the box until the dog's head becomes centered in the original picture. Once the head is centered, return to the Navigator palette and move the slider to the left toward the small mountains until you can see the whole picture again.

NAVIGATOR

It is important to be familiar with the Navigator and its use. The object of step 11 is to provide an opportunity to see how this tool works.

Step 12

Now we are ready to move to the background layer. In the Layers Palette, click on the Layer Visibility icon (the eye). Then, click on the background layer to activate it. Zoom in on the area containing the woman's legs and shadow. Press the letter "L" to bring

up the Lasso tool. Using it, draw a small circle around a grassy area. Then hold down the Command + Option keys on the Macintosh, or the Control + Alt keys on Windows. You will notice a black arrow superimposed on top of a white arrow. This allows you to duplicate any selection without having to copy and paste into a layer.

This process can be repeated by continuing to pick up the same segment of grass, then drag and drop it over any area containing the woman's legs and shadow.

PATTERNS

Again, avoid creating obvious patterns in the area that you are changing. Patterns call attention to your work!

Step 13

Although Photoshop has its default set to Precise, it is important to see the outline of the brush. Before you start painting in Photoshop set the painting cursor to Brush Size and the other cursors to Precise (Edit> Preferences>Display & Cursors).

Step 14

The final step is to flatten the image. (*Note*: The image must always be flattened before it is printed by a lab or service bureau.) Go to the Layers palette and click on the black tri-

angle at the top of the palette. Select Flatten Image from the pop-up menu. This will combine all layers into one as the background layer. (*Note*: A warning will pop up and ask you if you want to apply the layer mask. Click on Apply.)

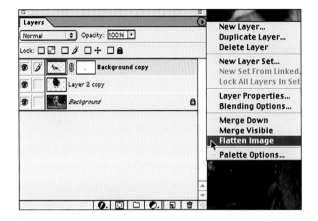

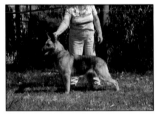

Before correction (above) and after (right).

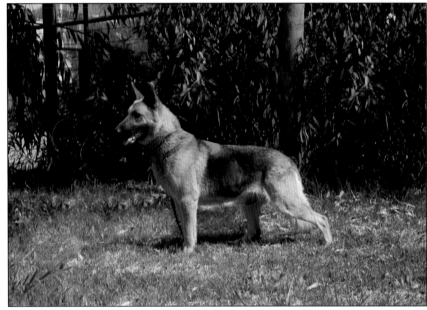

▷ LAYER MASKS AND MODES

Example 1: Fairy. In this section we will examine Layer Modes. We will begin with two photographs that will be merged together using layers and layer masks. The first image is a portrait of a beautiful toddler in a fairy outfit. The other photo is the flower the fairy is to be placed on. Both are seen below.

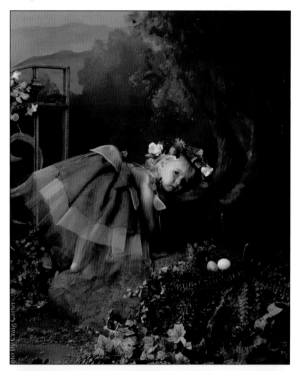

Step 1

Open both images in Photoshop. Position and size the images so they can both be seen on screen at the same time.

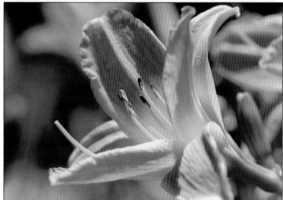

Step 2

Duplicate the background layer of the fairy image, so the original image will not be altered when she is extracted from the original image.

Step 3

Go to Filter>Extract and click on it. When the Extract dialogue box pops up, choose Smart Highlight.

Step 4

Select the Highlighter tool (at the top of the tool box) and select the entire subject by moving the tool/cursor around the subject.

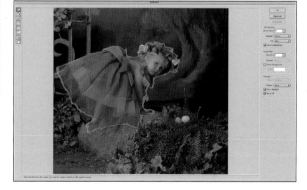

Step 5

Select the Paint Bucket tool and click on the subject to fill it.

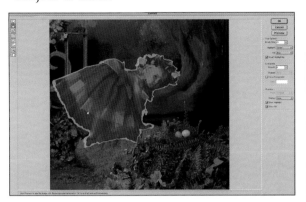

Press the Preview button to preview the extraction. In this case, the fairy must be perfectly extracted, and it will need some clean-up work—work that is readily visible at this stage (below, top).

In order to see clearly what needs to be cleaned up, choose White Matte.

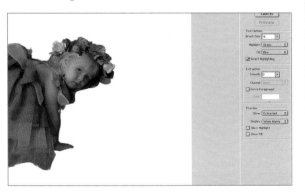

As discussed in the last lesson you will use the Cleanup tool in the Extraction-tools palette to clean up any stray pixels. To view the edge of your extraction, you may choose to click on Black Matte.

HISTORY PALETTE

Another concern to keep in mind is the cumulative nature of the History palette. The History palette records every click of the mouse, providing you with a snapshot for each click. This is very good if you need to go back to undo or check previous work. However, this takes up RAM for each stored step. If you have completed a task, and won't need to check your work from that point backward, or you have limited RAM in your computer, it is important to purge the History palette periodically. To accomplish this, go to Edit > Purge > All. A warning dialogue box will appear stating that this request cannot be undone. Do not fear the warning—just click OK or hit the Enter/Return key, and get on with the job!

Step 6

When you are sure your extraction is absolutely perfect, press OK, then press "V" (the keyboard shortcut to bring up the Move tool) or select the Move tool from the tool box. Place the cursor in the middle of the extraction (in the portrait) and hold the mouse button down. Then drag and drop the extraction into the picture of the flower and place it on the petal.

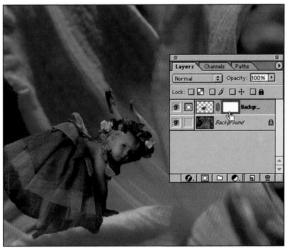

Go to Edit>Transform>Rotate to turn the fairy to the perfect angle.

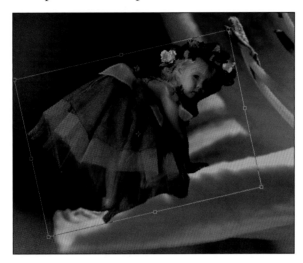

Step 7

Create a layer mask so you can trim around the fairy to make the fit even more perfect. Next, paint on the layer mask with black to erase part of the costume. In other words, you are trimming unwanted material from the bottom of the extraction.

Step 8

A soft glow around the fairy will give the rest of the illustration the beauty of a "fairy world." To create the glow, go to the small italicized "F" at the bottom of the Layers palette and click on it.

In the Layer Effects dialogue box you will note the Screen Opacity has a default of 75%. Leave this setting as it is. Also, the Noise is set to 0 and the Color selection is yellow. Elements is set to Softer with a spread of 0, and Size is set to 196. Choose Quality from the pop-up menu, and set Jitter to 58%.

Step 9

Flatten the image. The final image can be seen below.

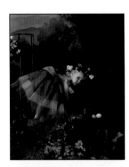

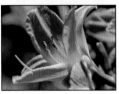

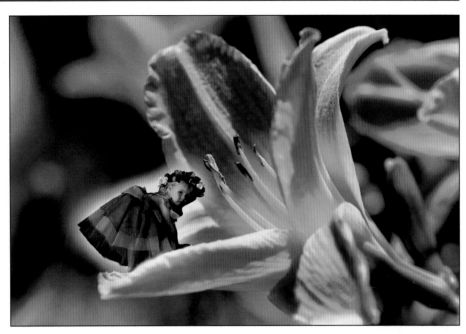

Before (above)
and after (right).

Example 2: Bride and Groom. Our second example illustrates a simple but exciting way to combine the application of Layer Opacity and Layer Transformation. It involves removing the bride's veil from covering the groom's face. This could be a common problem that prevents an otherwise beautiful wedding shot from being acceptable. Notice that half of the groom's face is obscured.

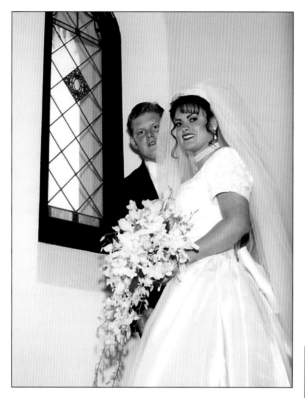

Step 1

First, scan your picture into Photoshop. Using the Lasso tool (with the Feather Radius of 5 points), draw a line around the visible cheek, lip, and inner edge of the eye areas. Hitting Command/Control + C, then Command/Control + V, will copy and paste this data to a new layer. Set the opacity slider in the Layers palette to about 68%.

Step 2

Flip the layer (Edit>Transform>Flip Horizontal). Hold down Command/Control + T to bring up the transform bounding box. Place the cursor outside the box at the upper right corner of the box, and the rotation arrow will appear. Rotate the box counterclockwise until the eye and ear are aligned. The sides of the face do not match perfectly, however. Press the Command/Control key to distort the layer, using the handles to make the groom's face fatter and to line up the ears. When you have the face the way you think it should be, press Enter/Return to set

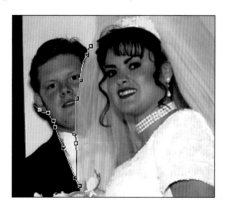

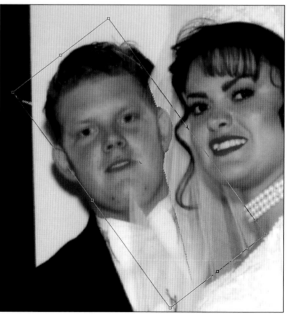

the transformation. Then, increase the layer's opacity to 100%. Use the arrow keys to move the layer into its final alignment.

Step 3

To remove the moles on the left side of the groom's chin, use the Lasso tool. Draw a small circle on the chin next to the area where the moles are using the Lasso tool. Click and drag holding the Command + Option (Mac) or Control + Alt keys (Win dows) and drop the selection over the moles.

Step 4

Circle a swatch of hair just above the veil with the Lasso tool. Then, copy and paste the selected area to form layer 2. Select the Move tool, and drag layer 2 into place to form a natural hairline. Duplicate layer 2 two

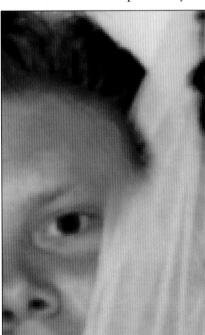

more times, and move the duplicates into place. Click the layer-visibility icon (the eye) on the background layer, then go to the black arrow on the Layers palette and click on Merge Visible (as in the previous example) to join these three layers (layer 2 and its two duplicates).

Step 5

Now, we need to align the layered hairline until it blends in naturally with the hairline on layer 1. Use Transform to approximately line up the hairline (Command/Control + E + Enter).

Step 6

Click on the background layer, then press "S" or select the Clone tool. Set the opacity to 50% in the Options bar. (*Note*: The opacity this can be set easily by using the number keys. Each number correlates to a percentage (i.e., 1=10%, 2=20%, etc.). Now, take a reading on the dark area of the groom's hair by hitting Opt/Alt and clicking, then move the cursor to the left side of the groom's face.

Clean up all remaining remnants of the veil so it appears to hang naturally without covering any part of the groom's face. This process will take you a little time to complete. The tuxedo may shine through rather than appearing as a dark area under the veil. If so, you may need to return to layer 2 and use a layer mask to make the tux appear as a dark area.

Step 7

Create a new layer. This new layer will be used to create a new veil along the remaining edge where the old veil was removed. Select the veil on the right with the Lasso tool and align it with the hanging part of the veil.

Copy and paste the selected area, then transform. (*Note*: If you select parts that do not fit right, simply erase the undesirable part of the layer.)

Step 8
Create layer 4 by using the Lasso tool to copy the groom's ear. Make sure the ear is properly placed using whatever alignment techniques are required. To make sure the ear is properly lined up, go to the tool box and open the Ruler. Anchor one end on the top of the stable ear, and the other end on the top of the replacement ear. Be sure the line runs right on top of the eyelids. It will, once again, appear as if the veil is over the groom's ear. Set the Opacity to about 40% (using your own judgment on this setting to create a realistic effect). Then, flatten the image.

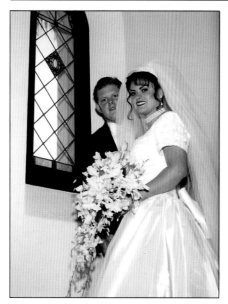

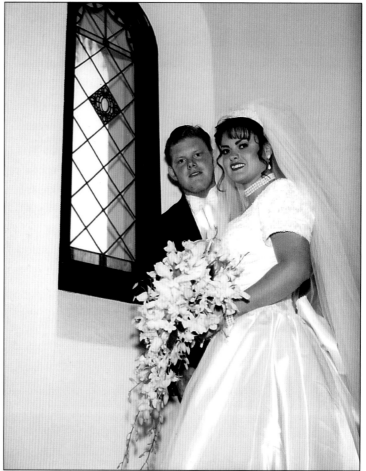

Before correction (above) and after (right).

▷ LAYERS WITH DODGING AND BURNING TECHNIQUES

The terms of dodging and burning refer to professional dark room techniques for darkening or lightening parts of the image. These techniques may be used when a person wants to create either a shadow or a highlight on the final image.

In a darkroom, dodging is completed by holding an instrument between the light and the paper to decrease exposure. Burning is the opposite, allowing light to strike and increase the exposure on a specific area of the image.

In Photoshop, the icon for the Dodging tool resembles a paddle, and the icon for the Burning tool resembles a curled hand. We can use these tools, but they tend to provide a harsh effect. For a more subtle effect I often use layers with soft light.

Example 1: Hana and Lindsey. To learn this technique, we will look at two images. First, we'll look at an image of two little girls named as Hana and Lindsey.

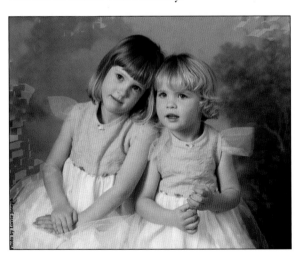

Step 1
Go to the Layers palette and hold down the mouse button, then click and drag the background layer onto a New Layer icon at the bottom of the palette. This creates a copy of the background so you can make changes without changing the original image in any way. (If you form a habit of doing this on every project, you will find that it will save you time and money.)

Now hold down the Opt/Alt key while clicking on the Duplicate Layer icon at the bottom of the Layers palette. This will open the New Layer dialogue box. After you select the Soft Light mode, the option "Fill with Soft-Light-Neutral Color (50% gray)" will appear. Check the box to select this option and click OK. Photoshop will create a new layer filled with 50% gray.

Step 2
Open the Swatches palette (Window>Show Swatches).

The top two rows of the Swatches palette are gradient shades of gray. Choose a light gray (the second in the top row) and select it by clicking on it. Select the Paintbrush tool with

the Airbrush option in the tool box and press the 2 key (the keyboard shortcut for 20% opacity). Make sure the Normal setting is selected in the Options bar. Paint the whites of the girls' eyes on the gray layer you have created. You can turn off the eye next to the background layer and its copy in the Layers palette by clicking. This will reveal the work you have actually done to the eyes. On the gray layer, you will notice that there are lighter spots in the middle which act as a bleaching agent to the eyes, leaving the original image data intact.

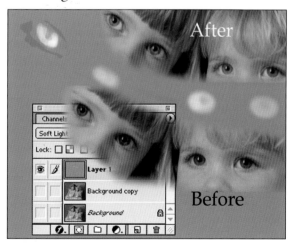

Step 3

To darken the corners of the image in a very subtle way, choose a shade of black from the end of the second column in the Swatches palette. Then click on the Gradient tool in the tool box (or simply press "G"). Click on

the small black down arrow in the Options bar at the top of the screen, and set the foreground color to transparent. (You will be able to identify that option because it is illustrated by black going diagonally to a checkerboard pattern in the second square from the left in the Gradient tool box.) Click on the Foreground to Transparent square to identify that option.

Now go to Show Rulers (Command/Control+R) or View>Show Rulers, then click on the ruler at the top of the screen and pull

down. As you do this, you will pull down and place two horizontal guides. Place one on the 3" line and one on the 5" line (evenly placed from the corners [on an 8"x10" image]). Then place two vertical guides by clicking and pulling in from the ruler to the left of the image. Place one on the 3" line and one on the 7" line).

drag from the corner to the point where the guides cross in each of the four corners. (*Note*: make sure you are on the gray layer when you click and drag.) You will get a beautiful, natural blended effect, and this image is now complete.

Step 4
Now you are ready to create a gradient shadow to produce darkened corners. Click and

Step 5
When all dodging and burning is complete, it is time to flatten the image. The final image is shown below.

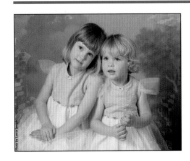

Before correction (above)
and after (right).

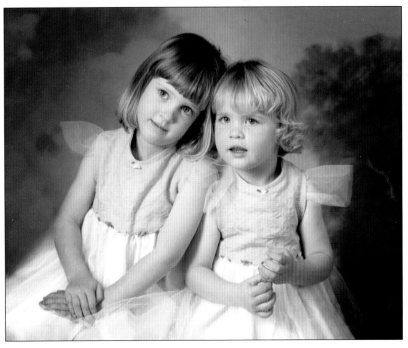

Example 2: Bruises. While the example in the previous section was a relatively simple one, the techniques you have learned can be applied in many situations. We will revisit these techniques when exploring the process of eliminating bruises in the next illustration.

The picture shown below was taken of this poor woman before she boarded an airplane for Nebraska. It was the last time she was photographed with her twin sister for a publication. She said she looked much worse than she felt, but just to look at this picture causes me to feel pain.

Step 3
Start painting on the bruised part of the face with a soft brush the size of the bruise.

You will notice the bruised area becoming more toned down as you paint. However, do not attempt to entirely remove the bruised area at this time or you will find the image turning milky white instead of a natural skin tone. In the next section we will remove the entire bruised and shadowed areas using Channels.

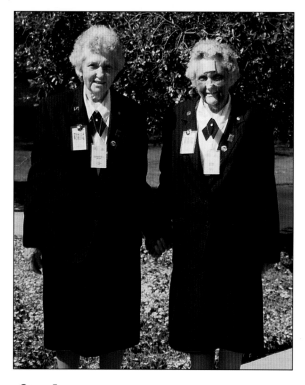

Step 1
First, as a matter of routine, we will duplicate the background layer. To do this, hold down Opt/Alt and click on the Duplicate Layer icon at the bottom of the Layers palette.

Step 2
In the Color Swatches palette, choose 15% gray, the third swatch from the left at the top of the palette.

▷ USING THE CHANNELS PALETTE

Images have one channel per color. Four-color (CMYK) images have four channels, three-color (RGB) images have three channels, and black & white pictures have only a single channel (black). Using the Channels, colors can be readily separated out. In the next example, we will use the channels in this CMYK image to remove the remaining bruised area. This is a challenging job for a retoucher. The first task to accomplish is to isolate the black in this image.

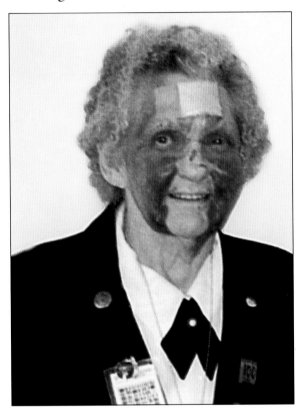

Step 1
Open the Channels palette by going to Windows>Show Channels.

Step 2
Move the cursor to the black channel (bottom of the Channels palette) and click on it. This process reveals the black information in the image.

Step 3
Click on the Dodge tool. In the Options bar, set the range to Shadows and the Exposure to 50%.

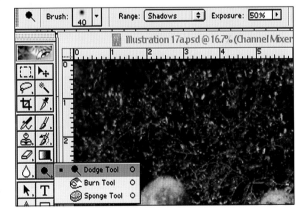

Step 4

Paint on all of the black areas of the face using the Dodge tool. Continue painting until all of the black areas are toned down.

You should periodically check your work by clicking on the CMYK Channel, or holding down Command/Control + ~ to bring up the CMYK channel. It is important to make a visual judgment to preserve the natural features around the chin area, mouth and nose, and the eyes.

Step 5

When the black part of the bruised area has been removed, you will notice that magenta shows through on it. Click on the magenta channel and complete the same process.

Complete the same procedure on each channel until the bruised area appears more normal. This may involve returning to a channel previously retouched. It is very important that your work be checked periodically by clicking on the composite CMYK channel.

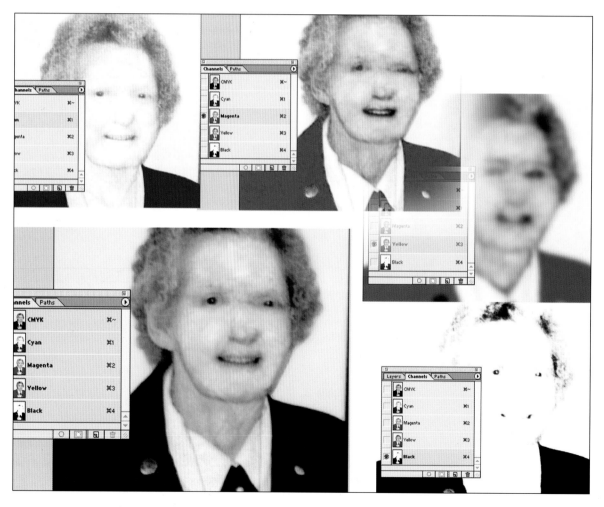

While this method may be time-consuming, it is one of the best ways to remove a bruised area without removing personal features and ending up with plastic-looking skin. Broader correction methods can remove vital characteristics—such as the wrinkles and age lines, in this case. (*Note*: It was important that these twins not be retouched, since the publication was celebrating their continuing service at the age of 84.)

Once the work is completed in the channels, finishing touches can be applied using other tools. For example, areas such as the bandage on her forehead could be removed by using either the Lasso or the Healing Brush and Clone tool. The twin sister's skin could be used to sample the data needed. However, even though the skin texture might appear to be similar, the features are not identical and may be difficult to match. In this instance, I did use the sister's skin to create "skin grafts"—being careful to match the features (such as wrinkles). I used the opacity settings carefully to control the way the grafts appeared.

I will examine other uses of channels in the following chapters.

Before correction (above) and after (right).

Before correction (left)
and after (above).

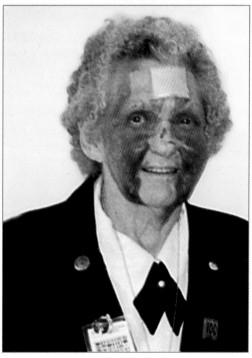

Photoshop Filters

There are four basic filters I use consistently in digital retouching projects. These are the: Lighting Effects filter, Noise filter, Gaussian Blur filter, and Unsharp Mask filter. It will be to your advantage to memorize the procedures for using these four filters so their processes become second nature to you. Artistic filters will also be covered here, as they are creative tools that can be used to enhance your work when you need to create a painted effect.

▷ LIGHTING EFFECTS FILTER

Lighting Effects can be used for correcting the original light and the overall lighting contrast in a photograph. This filter is used for many processes. For example, the color of light in any subject can be changed. It is important to first create a layer to complete the work in before beginning the actual corrective process. The original scanned image is preserved while the actual work is completed on a background layer copy when producing changes in the lighting effects.

Example 1: Captain's Bars. The first demonstration involves creating shiny silver captain's bars that are to be placed on a military painting. The second will demonstrate enhancement of lighting on a doggie portrait of a poodle, and the third will bring out the gold color of the metal in a more realistic way on a commercial machine. First the captain's

bars. (*Note*: All three demonstrations use the first two steps as a common opening process.)

Step 1

Drag the background layer onto the Duplicate Layer icon at the bottom of the Layers palette.

The captain's bars were originally dark, almost black rather than shiny silver (see above). It is difficult to tell that the bars are actually silver. They were scanned into a digital image to be inserted onto a painted portrait that the customer wanted to have copied, converted to 11" x 14" pictures, and mounted on canvas.

Step 2

Next, select the Marquee tool from the tool box. Set the Feather Radius to 0.

Step 3

Click and drag from above the captain's bars to the bottom right corner to include all of the bars, plus some room around them.

Step 4

Select the Magic Wand tool from the tool box (or press "W"). Set the Tolerance to 50, then check Anti-Alias and Contiguous. Leave Use All Layers unchecked.

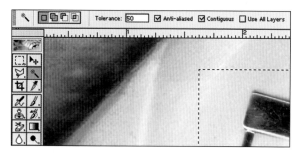

Hold down the Opt/Alt key while clicking within inner part of the bars. This will instantly and effectively select just the captain's bars.

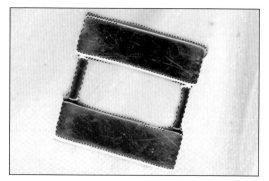

Next, zoom in by holding down Command/Control and the "+" key. (This zooms in to 100%. When the "+" key is pressed again, it zooms to 200%. The percentage view doubles each time the "+" key is pressed.)

When you have zoomed in to 100%, you'll see there are four places in the selection that are not perfect.

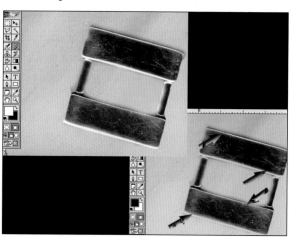

Click on the Quick Mask icon at the bottom of the tool box to fix these problems. When you select Quick Mask, a red color will appear, covering everything except the selected area. Choose a brush from the Brushes palette (set at 100% opacity). With the Quick Mask active, painting with white as the foreground color will erase the Mask, while painting with black will restore it.

Erase the red on the bars in the areas that you want to be selected. When you are finished, press "Q" (for Quick Mask), then click

the Edit-in-Standard-Mode icon at the bottom of the tool box to convert the Mask back into a selection.

Step 5

Hold down Command/Control + C to copy the selection. Paste it into its own layer by pressing the Command/Control + V (or press the J key to accomplish the same task).

Step 6

Open the Lighting Effects filter (Filter> Render>Lighting Effects). A dialogue box will appear with several options. Under Properties, move the slider to select the following settings: Gloss=Shiny, Material= Metallic, Exposure=Over and Positive Light. (You can experiment with changing the styles of lighting, and I highly recommend that you explore the various options.)

The final result achieved with the captain's bars is that they now appear as shiny silver with a 3-D effect!

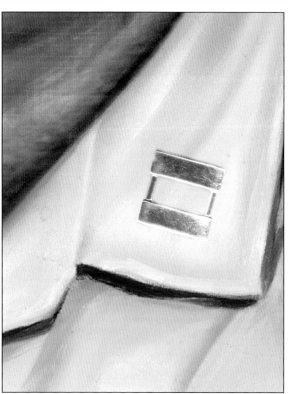

Before correction (right) and after (above).

Example 2: Poodle. This picture of a poodle needs to have its contrast increased. (To begin, repeat steps 1 and 2 from page 39.)

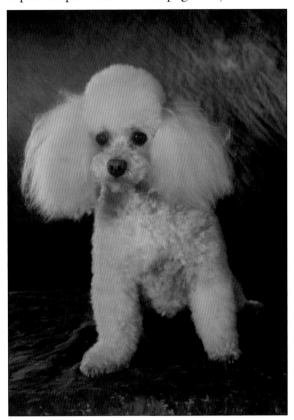

Step 3

Select Soft Spotlight (Render>Lighting Effects>Style>Soft Spotlight). Experiment with these settings until the poodle is highlighted in a natural manner. In this case, use the Directional Lighting Method, and the Properties selections: -11 Matte, +57 Metallic, +3 Overexposed.

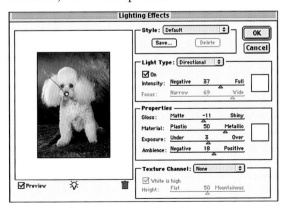

Step 4

Click on the Elliptical Marquee tool, and set the Feather Radius to 3 pixels. While holding down the Shift key, drag the Elliptical Marquee tool around the poodle's nose, then around each of the eyes, creating a loose selection around each feature. (*Note*: When highlighting multiple areas, pressing the Shift key will allow you to create multiple active selections.) Don't expect the Elliptical Marquee tool to drop exactly where you want it to. Using this tool almost always requires some trial and error. If you get frustrated, go to Quick Mask, as illustrated in the last image, and paint the selection exactly where you want it.

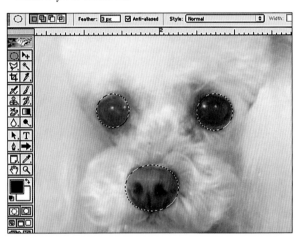

Step 5

Once the desired areas are highlighted, press Command/Control + H. This hides the selection outline.

Step 6

Select Lighting Effects (Filter>Render> Lighting Effects). This will bring up the Lighting Effects dialogue box.

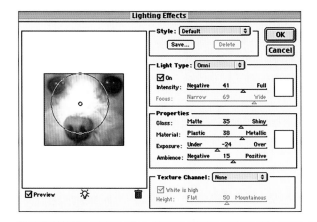

Use Omni Light to distribute lighting evenly on the nose and the eyes. What we are doing is creating a brighter nose and subduing the light on the eyes to make the blacks pop out more. When you have achieved the desired effect, click OK.

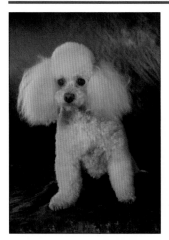

Before correction (above) and after (right).

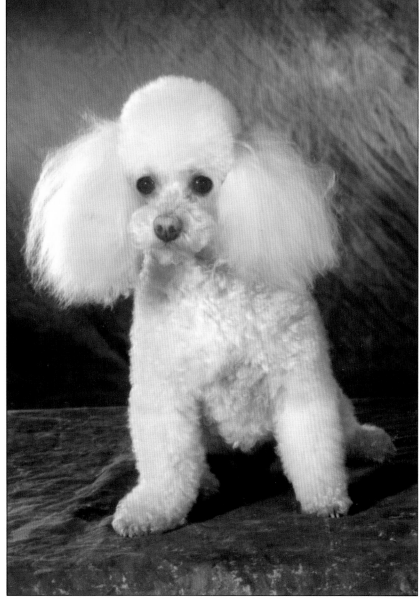

Example 3: Palm Trees. The task to be accomplished with this image is to replace the white light of the sun with a beautiful, bright golden light. To accomplish this, the sky pixels must be isolated in a soft, natural way.

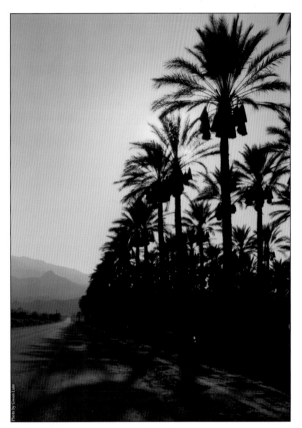

Step 1

Select the Magic Wand tool. Set the Tolerance to 50, check Anti-Alias, and choose Contiguous. Click on the sky of the background. Then, go to Select>Similar.

Go to the QuickMask mode by pressing the Q key. Then, select the Paintbrush and set it to Airbrush. Choose a large, soft brush from the Options bar.

Step 2

Choose white as your foreground color and paint on the sun area of the Quick Mask

(what we are doing is extending the sky selection to include all of the sun).

Step 3

Go to Filter>Render>Lighting Effects. Click on the square to the right of the Light Type box, and choose a gold color from the Color Picker. Choose Omni as the light type, then set the Intensity to -4. Under Properties, choose: Gloss=+35 Shiny, Material=+38 Metallic, Exposure=-24 Under, Ambience=-15 Negative. Select Green in the Texture channel, and check the White-is-High box. Set the Height to 100 Mountainous.

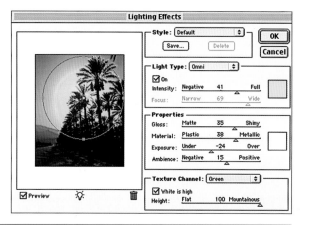

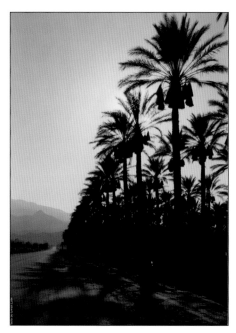

Before correction (above) and after (right).

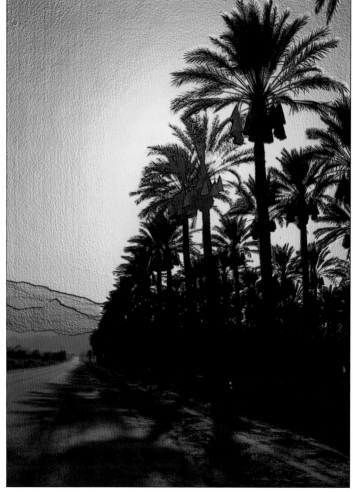

▷ NOISE FILTER WITH THE HEALING BRUSH

The Noise filter combined with the Dust & Scratches filter (which is located as a submenu within the Noise filter menu) is a very effective way to smooth out skin, then add definition back into it by adding noise—making the image look more natural. You will notice that the portrait below (an unretouched image of an attractive young lady) needs some retouching work to bring out the natural beauty of this subject.

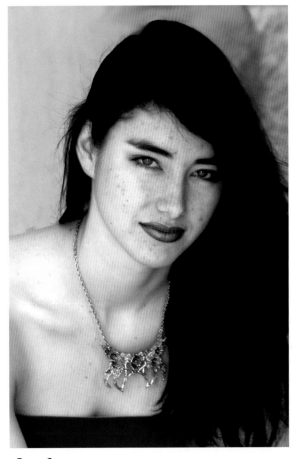

Step 1

Remember to duplicate the image by clicking and dragging the background layer onto the New Layer icon at the bottom of the Layers palette.

Step 2

The first step in correcting this portrait is to click on the Healing Brush (the tool that looks like a Band-Aid®) in the tool box.

Step 3

You will notice the Healing Brush will glow pink—the same color of an old-fashioned Band-Aid®. Like the Clone tool, you use the Healing Brush by placing the cursor over an undamaged part of skin, then pressing the Opt/Alt key and clicking. This process copies a target area of the unblemished skin. Then, move to the blemish and watch the magical transformation. When all blemishes have been removed, duplicate the repaired layer (you should now have three layers). You will be working on the top layer in the following steps.

Step 4

Locate the round circle with a white center at the bottom of the Layers palette. Hold down the Opt/Alt key while clicking on the Layer Mask icon. A black layer mask will become visible in the Layers palette.

Step 5

To make it active, be sure to click on the layer thumbnail and not on the layer mask of the background layer copy. If you click on the thumbnail, you will notice that it becomes outlined and a brush appears in the

square next to the eyeball. If you would like to see the way it is outlined, click back on the layer mask. Now, the layer mask is outlined in the small square next to the eyeball. This outlined area indicates which part of the layer is active.

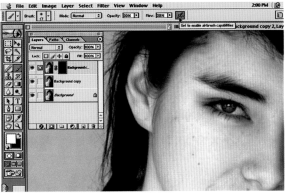

Step 6

Now apply a filter to the background copy. Go to Filter>Noise>Dust & Scratches. Set the Radius to 10 and the Threshold to 0.

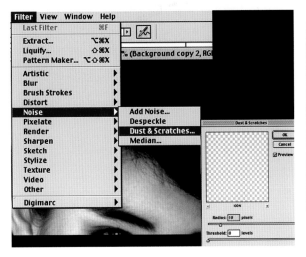

Step 7

Choose the Paintbrush tool from the toolbox and set the Opacity to 20%. Set the Flow to 20% and select the Airbrush mode with white as the foreground color. Click on the layer mask to activate it, and start painting.

Step 8

Click back on the layer thumbnail of the background layer copy to make it active. Choose Filter>Noise>Add Noise and the Add Noise dialogue box will appear. Insert 1.5% as the Amount value, and select Gaussian as the type of noise distribution. Be sure the preview box is checked, and watch what happens with high settings. Some images do not need as much noise as others, so make your decisions visually. What you see is what you get—and a little noise goes a long way. It is important to experiment with these settings.

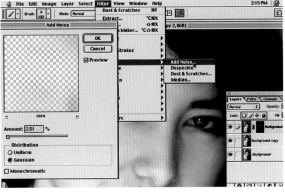

The final, retouched image is shown on the next page. I'm sure you'll agree that it's a big improvement!

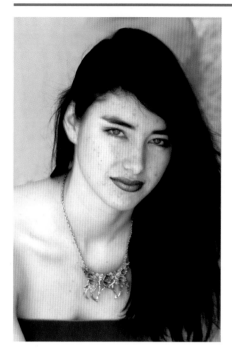

Before retouching (above)
and after (right).

▷ GAUSSIAN BLUR FILTER

When I think of the term "Gaussian." I think in terms of a photographic technique. The technique involves placing a piece of regular gauze in front of the lens, or stretching it over wire (such as a coat hanger) and passing it under the enlarger's lens to soften the picture through light diffusion. Photoshop's Gaussian Blur filter creates the same effect. The Gaussian Blur filter can, however, result in a blurry, mannequin-like effect on the skin texture. So when is it appropriate to use Gaussian Blur? The answer to this question is explored in the next image of a bride and groom in a beautiful setting (below).

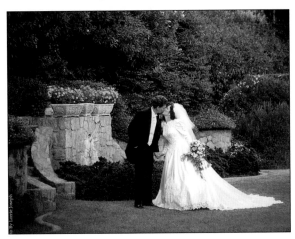

Step 1

Select the Elliptical Marquee tool from the tool box. In the Options bar, set the Feather

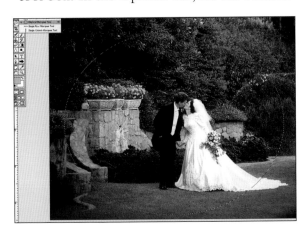

Radius to 180, and make sure Anti-Alias is checked. Click and drag the Elliptical Marquee tool over the image to create a circle around the bride and groom. Once the selection is made, release the mouse button.

Step 2

In order to blur the portion of the image *outside* the circle (rather than the portion with the bride and groom in it), it is important to select the inverse part of the picture. This can also be accomplished using a keyboard shortcut: press the Command/ Control key + Shift + I (for "Inverse") all at the same time. Or, you can go to Select> Inverse. To hide the dotted selection line (the "marching ants"), go to View>Hide Edges (or push Command/Control + H). Next, go to Filter>Blur>Gaussian Blur.

Step 3

In the Gaussian Blur dialogue box be sure to check the Preview box. Under Radius, play with the Pixels value to see what looks best. (*Note*: It may take a bit of time for the filter preview to load. Be sure this is fully loaded prior to pushing the OK button.)

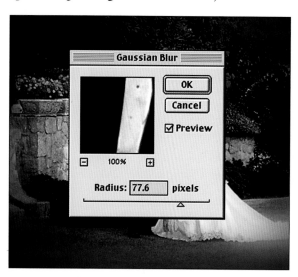

Once you have achieved the desired effect, push the OK button, and you have your final image. The results are shown on the facing page.

Note that the image in this illustration is a 300dpi image at an 8" x 10" size. This size image requires a higher Feather Radius (here, 180) than a smaller size image. A 4" x 5" image, for example, would probably need a Feather Radius of only 80 or 90 to achieve the same effect.

This tool is particularly useful for creating a different background without importing a secondary image (such as borders). Be creative, and use the Gaussian Blur filter in any way you find it useful!

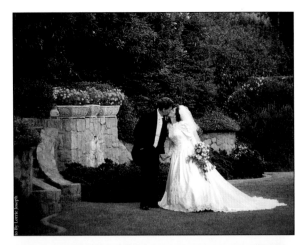

Before enhancement (right) and after (below).

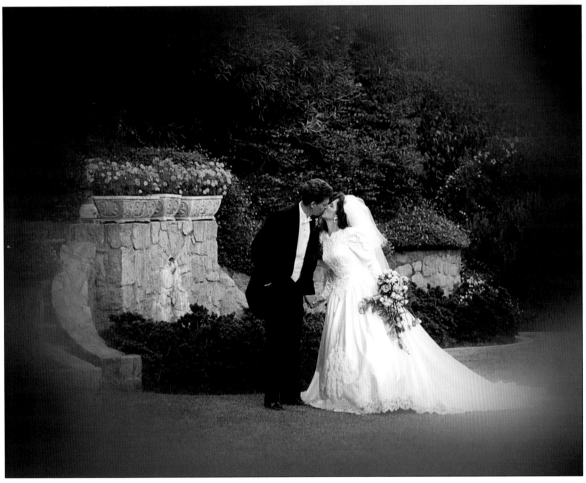

▷ UNSHARP MASK FILTER

This picture of a beautiful and very active two year old could be sharper. We can accomplish this by applying the Unsharp Mask filter.

Step 1

Open the Unsharp Mask dialogue box (Filter Menu>Sharpen>Unsharp Mask).

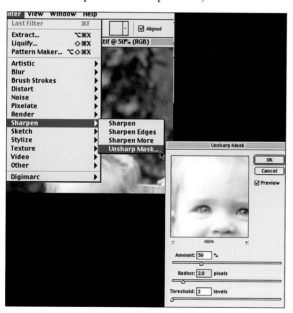

Step 2

I set the Amount to 50%, and the Radius to 2.0 (*Note*: When Radius settings are too high, the results look artificial. You should normally keep the Radius setting low to prevent oversharpening the picture.) I set the Threshold to 2. The threshold setting tends to return some of the original integrity of the image, and is also helpful in toning down the contrasty Radius effects. When the desired result is achieved, click OK.

Now, you will notice that under the Filter menu, "Unsharp Mask" is at the top. Click on this three times to re-apply the filter with the same settings (or hit Command/Control + F). Running the filter several times at a low intensity results in a more natural appearance than running it once at a high intensity.

Note the difference it makes in the final image of the child (below).

▷ DRY BRUSH FILTER

Step 1

Duplicate the background layer and open the Dry Brush filter (Filter>Artistic>Dry Brush). The Dry Brush palette will appear.

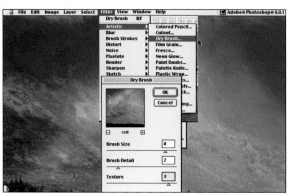

Step 2

Play with the sliders, and experiment with the different settings until the image appears as desired. Once the desired effect is achieved, click on the OK button.

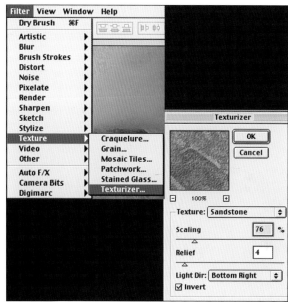

Step 3

Go to Filter>Texture>Texturizer and choose Sandstone. Set the Scaling to 76%, the Relief to 4 and click on "Bottom Right." Then, hit OK.

▷ DUST & SCRATCHES FILTER

When working with old photographs and old negatives, they are often received by the retoucher with multiple scratches, stains, and fingerprints. (*Note*: Some scanners use Digital ICE®, a processor that eliminates scratches, dust and surface defects automatically during the scan. Those of you who own such a product can skip this section of the book.) While software such as ROC® restores faded image color and GEM® reduces film grain, we must look beyond the scanner processing for help.

Adobe Photoshop has developed a great tool in the Dust & Scratches filter. The primary problem I have experienced with Dust & Scratches is that it tends to cause the image being processed to become out of focus. Using a few simple tricks, however, we can use this filter without producing a blurry effect on the entire photograph.

Our demonstration image is one of my favorite negatives from a trip to Alaska in 1985. Although I try to keep my negatives clean, when I scanned this one I discovered there were many scratches and spots of dust on it. This section demonstrates how untold hours of frustration can be prevented in situations like this.

Step 1

Open your image in Photoshop.

Step 2

Duplicate the background layer. Go to Filter>Noise>Dust & Scratches.

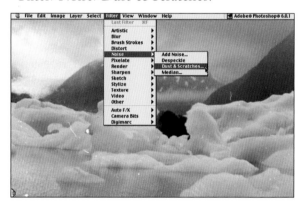

The Dust & Scratches dialogue box requests settings. Any number over 1 pixel in the Feather Radius will make your photo go out of focus. The way I judge what value to assign to Feather Radius is by evaluating whether the largest spot I want to remove is removed or not. In this case, I put in 6 pixels. Be sure the preview box is checked. Set the Threshold level to 0. It is pretty scary for

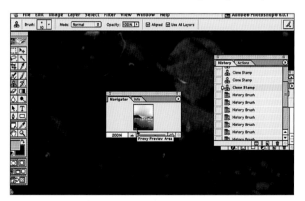

a professional photographer to see their valuable asset that far out of focus—but do not allow fear to overcome you. Click OK to apply the Dust & Scratches filter to the image.

Step 3
Go to the History palette and click on the little camera at the bottom of the History palette. Click on it to bring up a new snapshot of the history state with the Dust & Scratches filter applied to it.

Now, go to the top of the History palette and double-click on the New-Snapshot icon. Name the snapshot "Dust & Scratches," then click in the small blank square next to the snapshot. The History-Brush icon will appear, indicating that you can now paint from that state. Before proceeding, click on the next-to-last state in the History palette.

That essentially throws the previous state away.

Step 4
Open the History Brush in the tool box, and choose a small brush. Then, click on the Navigator palette, zoom in to the bottom, left-hand corner at 200%.

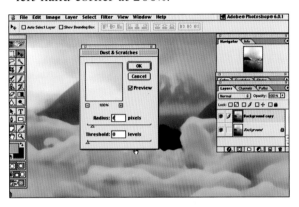

Step 5
With the History Brush, you can now paint freely from the Dust & Scratches history snapshot. Note that the dust and scratches are removed only in the areas where you choose to put the brush. Systematically clean

up the dust and scratches all the way up to the top of the image, then back down like mowing a lawn!

Step 6

Some spots are too big to be removed in this manner. The Clone tool can be effective when used on those areas—again, using the smallest possible brush. This image took me about an hour and a half to retouch—a good argument for dusting your negatives and scanning equipment (be sure to keep your digital camera free from dust, as well). I will say this: the computer is still faster than doing it the old fashioned way using a brush and dyes. Placing a humidifier in the room where you keep your negatives might be helpful for reducing the dust level.

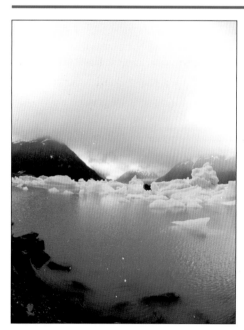

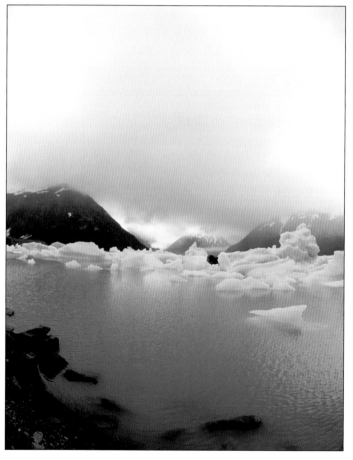

Before correction (above) and after (right).

Creative Photo Enhancement

▷ COLOR RANGE SELECTION

The Color Range selection tool allows you to select portions of an image based on color. This is one of the best tools for selecting pixels of like color, and will be demonstrated first. This illustration will be completed using the Replace Color option. In this image, the task is to isolate the white dust spots from a silhouetted black sunset.

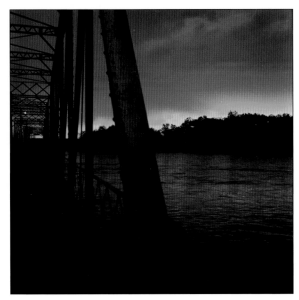

This image was scanned from a negative I took almost thirty-five years ago on CPS film. The negative was obviously covered with dust and scratches—so it's a good demonstration of how easy it is to use the Dust & Scratches filter in conjunction with Color Range selections.

Problem areas are much easier to isolate in images with strong contrast, such as the sunset in this photograph. Here, the problems appear as white spots against a black background. (*Note*: As illustrated in the photo in the previous section, images with a lot of white [or light] areas that do not contrast much with the problem white spots do not lend themselves as readily to this technique.)

Step 1

First, duplicate the background layer. View the image at 200% (Hold down the Command/Control key and press the "+" key twice). Go to Color Range (Select>Color Range). The Color Range dialogue box appears on the screen.

Select	Filter	View	W
All		⌘A	
Deselect		⌘D	
Reselect		⇧⌘D	
Inverse		⇧⌘I	
Color Range...			

Step 2

In the Color Range dialogue box, move your cursor over the image preview. It turns into an Eyedropper. Click on the black silhouet-

ted area of the image. At the top of the dialogue box, the Fuzziness slider controls how widely any similar colors can vary from the one you clicked on and still be selected. The smaller the number, the more precise and fine-tuned the color selection is. As the slider is moved to the higher numbers, the more liberally it will define your selected color. I

have chosen a setting of 40. Note that when the black portions of the actual image are selected, they show up as white in the Color Range box. White represents the color *revealed* in the selection that shows up in the dialogue box. Check the Invert option box and click OK. Now, everything except the bridge and silhouette are selected.

Step 3

Go to the Dust & Scratches filter. In the dialogue box, choose 3 as the Feather Radius,

and then click OK. Notice that the image has almost instantaneously lost most of its spots. Now, on to the next step.

Step 4

The small white spots remaining in the silhouetted portion of the image are to be isolated and removed. Press Command/ Control + Shift + I, and the selection will change to an inverse view with the black parts revealed.

Step 5

There still remain some white spots apparent in the black area. Go to Select>Save Selection. This will create an Alpha Channel. Deselect the image by hitting Command/ Control] + D. Go to the Channels palette and click on the Alpha channel to activate it. This clearly reveals the white spots in the black, allowing them to be painted out using the Paintbrush tool, set to 100% opacity.

Step 6

Go to Select>Load Selection. In the dialogue box, an option to load the Alpha channel as a selection appears. Click OK.

Step 7

Press Command/Control + H to hide the selection line (the "marching ants"). Go to Image>Adjust>Replace Color. Move the dia-logue box to the side of your screen until the image under it is clearly visible. In the dialogue box, click on the black area on the image with the Eyedropper tool, and move the bottom Darkness–Lightness slider all the way to the left to darken all the silhouetted area to black, providing a high contrast between the beautiful sunset and the bridge.

Before enhancement (above) and after (right).

▷ THE PERFECT BACKGROUND

To effectively develop a "perfect background" on this children's portrait, it is important to begin with a clean selection on the background area. Various tools that have been introduced in earlier sections will be used. Additional tips and tricks for channel and layer options will also be introduced.

Step 1
Open the Layers palette and create a duplicate background layer.

Step 2
Click on the Magic Wand tool. In order to select all colors that were picked, make sure the Magic Wand is set to a Tolerance of 32, and that the Contiguous and Anti-Aliased boxes are both checked. Move the cursor to

the image and hold down the Shift key. Click ten or eleven times on various parts of the background until you have selected the background (make sure the you release the mouse button before you release the Shift key).

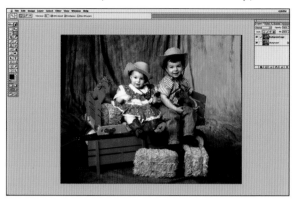

Step 3
Since there are so many colors in the background that are also in the hay (and throughout the image), it is important to fine-tune the selection. My favorite way of doing this is to convert the image into a Quick Mask. This is accomplished by clicking on the Quick Mask tool at the bottom of the tool box (or by pressing the Q key).

Step 4

The default Quick Mask color is red. However, because there is so much red in this image (the red wagon and the red dress), this would make it difficult to differentiate the mask. The color of the Quick Mask can be changed by double-clicking on the Quick Mask tool in the tool box.

Step 5

Choose the Paintbrush from the tool box (or press the B key). Select a hard-edged brush from the Options bar.

Step 6

Now paint on the mask. Using white as the foreground color acts as an eraser; using black acts as paint. What you are doing is painting on a mask to modify the selection, making a perfect opening for a replacement background. The object is to eliminate the original studio background and replace it with an outdoor background one—while producing a blended appearance between the indoor and outdoor aspects. (The ability to provide this transitional effect is what separates good retouching work from the bad.) With black as the foreground color, paint within the objects with a large, hard-edged brush. Paint over the hay and other parts within the image that shared yellow pixels with the background.

I chose to keep part of the original background here to create a foundation for the children to sit on. So I used a small, tight brush to paint around the hats and wagon. To paint around the sides, I chose a 300-pixel brush to help create the transition.

You may find it helpful to use the keyboard shortcut (the X key) to toggle between the brush its functions as an eraser and a paintbrush, toggling the foreground color between black (acting as an paintbrush) and white (acting as an eraser). The left and right bracket keys can also be used to zoom the brush size in and out. It is seldom necessary to change the brush options, unless a transition from a hard-edged brush to a soft-edged brush is needed.

Zooming in and out while completing the task can be accomplished using the Navigator palette, as covered in previous sections. An hour should be allowed for this job. Remember, the most important part of any retouching job is that of providing a clean

selection. Continue cleaning up the background until it is satisfactory, then click back on the Edit-in-Standard-Mode icon (bottom of tool box).

Step 7

You may think you have the perfect selection at this point—but there are two things that still need to be accomplished before the task is completed. Before proceeding, make sure the selection is saved. (I have a rule of thumb which I follow: anytime it takes me over ten minutes to complete a selection, I save it.) To do this, go to Select>Save Selection.

In the dialogue box that pops up, you can choose a name for the selection (here, I named it "Background").

Step 8

Open the Channels palette (Window>Show Channels). Click on the new channel to activate it.

Step 9

When you click on the background channel, the screen will go black and white. This reflects the selection in the form of black (to hide) or white (to reveal) your image. In this form, all the dirty-looking parts (fringe pixels) that are left over from the original background data can be easily cleaned up. Zoom in to 20% (Command/Control + "+" key). Make sure the foreground color is set to

Fringe Pixels

white, and start cleaning up the black pixels left on the white background in your selection. As noted in step 6, the "X" key can be used as a toggle switch.

To clean around straight lines (such as around the wagon), hold down the Shift key while dragging along the line. (To ensure a perfect line, I make one stroke at a time, then release the Shift key. If you do not do this, you end up with a diagonal line going from the last place on the line to wherever you start painting.) Be careful not to get too close to the transitional soft brush selections on the sides of the image.

Step 10
Click on the RGB Channel in the Channels palette. This process restores the image to normal color.

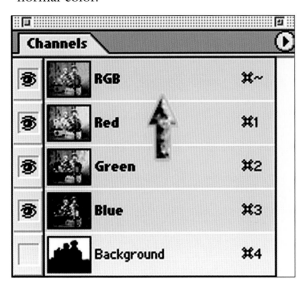

Step 11
In order to restore the selection indicator (the "marching ants"), go to the Channels palette, locate the background channel, and click and drag it into the circle at the bottom of the palette.

Step 12
The selection is now perfect and ready for the new background to be inserted. Images from CDs or any meaningful source can be imported to use as a background. (In this example I brought in an image of a local scene that I had on file.) Open the image you will be using for the background.

Step 13
In the new image, Go to Select>All, or use the keyboard shortcut of Command/ Control + A. Then press Command/Control + C to copy, and return to the children's portrait. Go to Edit>Paste Into or use the keyboard shortcut Command/Control + Shift + V. Now the project is complete.

You can see the final result of this process on the next page.

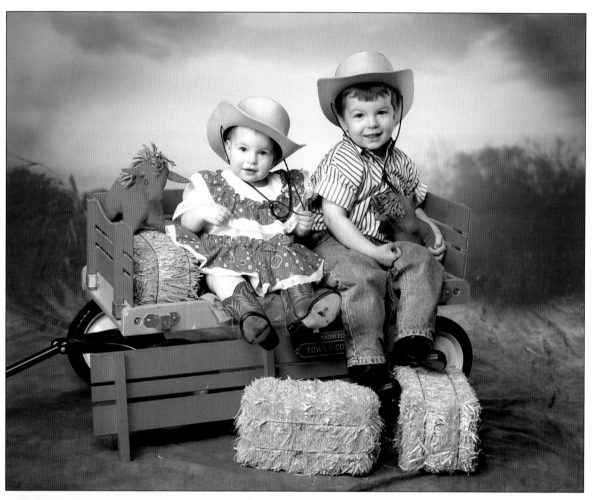

Before enhancement (left)
and after (above).

▷ ADDING A BORDER

To enhance an existing background you might want to add a border to the picture. This can be done in a couple of ways. One way is to use one of the many programs and plug-ins that create borders automatically. The creative Photoshop user can use the program to develop his/her own style of border. For this example, we will open a touching portrait of a father and his young daughter.

Step 1

Draw a loose selection around the outer edge of the picture by using the Lasso tool, making sure the selection is asymmetrical.

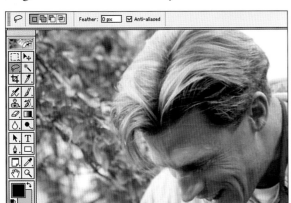

Step 2

Once the border area is selected, save the selection (Select>Save Selection).

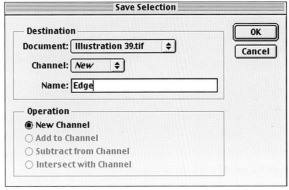

In the Save Selection dialogue box, name the new channel "Edge" and click OK.

Step 3

Deactivate your selection.

Step 4

In the Channels palette, click on the Alpha channel to select it as the active channel. The image will disappear (temporarily) and only a black border will be visible.

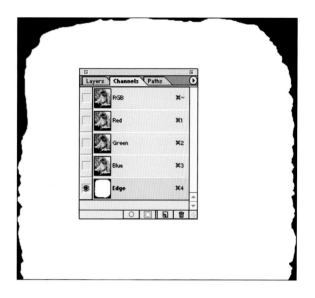

Step 5

Open the Diffuse filter (Filters>Stylize>Diffuse). This brings up the Diffuse dialogue box.

Make sure you are in the Normal Mode. Click OK.

Step 6

Zoom in to check on your work.

Step 7

Intensify the effect by pressing Command/Control + F, repeating until the border

seems to have a torn appearance around the edges.

Step 8

Open the Gaussian Blur filter (Filter>Blur>Gaussian Blur). When the Gaussian Blur dialogue box appears, set the Radius to 1.0 pixels. When the blur is applied, it softens and blends the edges of the border area into the background.

Step 9

Go to the Channels palette, then click and drag the Alpha 1 channel into the Load-Channel-as-a-Selection icon at the bottom of the palette. Click on the RGB channel to view the image of the father and daughter with a selection around the edge of the image.

Step 10

Invert the selection (Select>Inverse) and press the Delete key. At this point, more effects using filters and channels can be tried to create multiple border options.

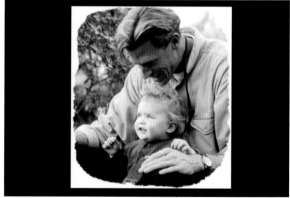

Step 11

The second edge will be created from the saved channel. Create a copy of the Edge channel by dragging it onto the New-Channel icon at the bottom of the Channels palette.

Next, drag the Edge channel into the dotted-circle icon at the bottom, of the Channels palette. This action loads your channel as a selection.

Step 12

Click on the Edge Copy channel in the Channels palette.

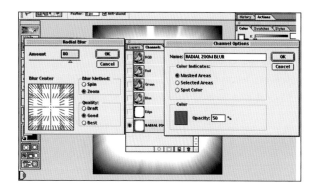

Step 13

Go to Filter>Blur>Radial Blur.

In the Radial Blur dialogue box, choose the following settings: for Amount, choose 80; for Blur Method, select Zoom; for Quality, choose Good.

Step 14

In the Channels palette, double-click on the Edge Copy channel. When the Channel Options dialogue box comes up, name the Channel "Radial Zoom Blur" and click OK. Click and drag this new channel into the Load-Channel-as-a-Selection icon at the bottom of the palette. Hold down the Command/Control + I keys to inverse your selection. Press Opt/Alt Key + Delete/Backspace to load the foreground color as the edge color.

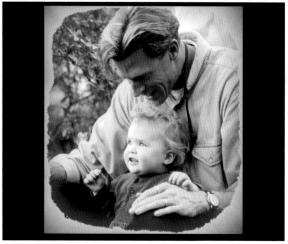

Step 15

To complete this edge, we can go back to the original Edge channel and click/drag it into the Load-Channel-as-a-Selection icon

Step 16

At the bottom of the tool box, choose white as the foreground color. Then go to Select>Modify>Border. In the dialogue box, choose 10 pixels.

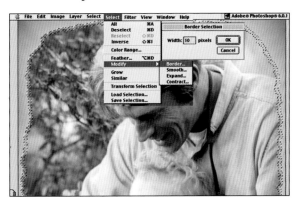

Step 17

Drag the Alpha channel to the trash (located at the bottom of the Channels palette). (*Note*: Before you send an image to a lab or service bureau, be sure that all extra layers and channels are deleted and the image is flattened.)

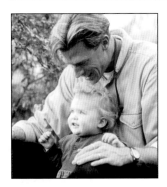

Before enhancement (above) and after (right).

▷ IMAGES IN MOTION

Let's take the methods we have learned and apply them to developing some creative images. We will open up a beautiful portrait of a little angel and create motion in her wings.

Step 1

Go to Select>Color Range and click once on the white wings. Then choose the "plus" Eyedropper tool to select all of the white wings and the foreground cloud. Be careful not to select parts of the little girl's eyes. If parts of the eyes *do* become selected, this problem can be corrected in the Quick Mask mode after the Color Range has completed its task. (*Note*: Do not go to the "–" Eyedropper tool and click on the whites of the eyes—this will not allow you to subtract the color from the eyes).

Step 2

Press Command/Control + J to paste the wings into their own layer. In the Layers palette, click on the black arrow at the top to bring up a pulldown menu of layer options. Choose Show Layer Properties. Name the layer "Wings," and click OK.

Step 3

With the Wings layer highlighted in the Layers palette, go to Filter>Blur>Radial Blur. For Amount, choose 100; for Blur Method, choose Zoom, and for Quality choose Best. Be prepared to do something else while this filter renders (the Best Quality setting is what takes time). If you do not have sufficient power in your computer to complete this operation, just select Draft.

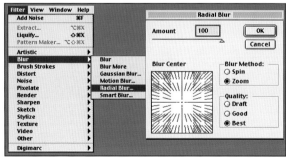

Step 4

If you are planning to send your image to a
service provider, flatten the image.

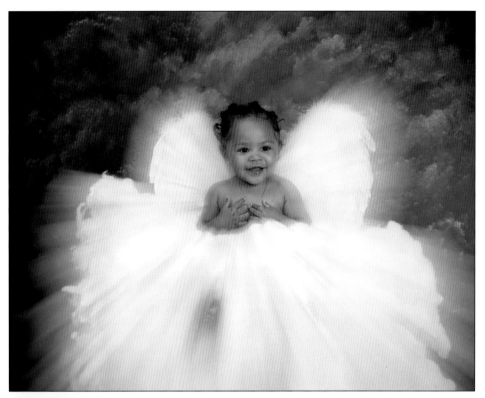

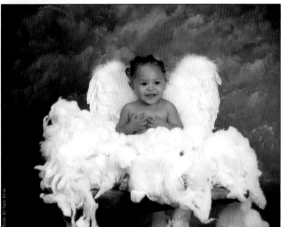

Before enhancement (left)
and after (above).

▷ ADDING SHADOWS

There are occasions where shadows can be used to enhance photographic effects. In the following example, we will be considering a natural-looking shadowing effect under the chin. Here it is used to enhance the natural beauty of the subject. The trick is to isolate the area that needs to be shadow from the feathers in the foreground.

Step 1
Duplicate the background layer by dragging it onto the New Layer icon located at the bottom of the Layers palette.

Step 2
Activate the background copy layer by clicking on it. Then go to Layer>Add Layer Mask>Reveal All). The shortcuts I shared earlier in the book can also be used—simply highlight the background copy layer, then click on the dotted circle at the bottom of the Layers palette. This will create a new layer mask.

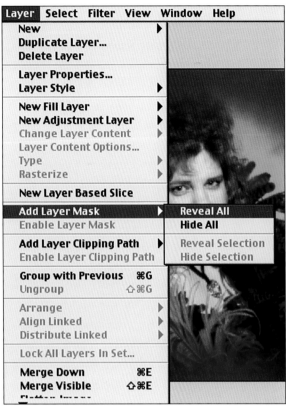

Step 3
Click on the image part of the layer to make that part active. Note the outline frame around the image part of the layer, indicating that part is active.

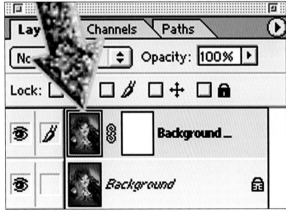

Step 4

If any of the painting tools are used on an image, it will always looks painted. It is for this reason that I prefer to create shadow effects from the original image data. In other words, I prefer to create shadowed results by darkening the image layer itself and transitioning parts of the original to it. To do this, go to Image>Adjust>Levels (or use the keyboard shortcut: Command/Control + L [for Levels]). Go to the middle slider in the Levels dialogue box and drag it to the left. With the Preview box checked, move the dialogue box over to the side of your screen so that you can see the result of the darkening on the image. The area of concern is the part under the chin, which should become almost black, eliminating the highlights altogether. I chose 0.52 as the value for the middle slider. Do not become overly concerned that the image is way too dark. We are going to save only the shadow areas that we like. The layer mask will help us to eliminate the objectionable areas.

Step 5

Click on the Layer Mask thumbnail in the Layers palette. This action selects the layer mask and outlines it. Go to the Paintbrush in the tool box by either clicking on the icon or pressing the B key on your keyboard. Select a large, soft-edged brush and choose black as your foreground color.

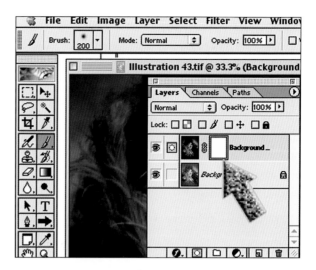

Begin painting on the layer mask to bring back the correctly exposed areas of the image with a 200-pixel brush to develop a final transitional blending between the two layers. Once the face is completed and the transition appears believable, move to a larger brush to bring back the upper background area, hair and eyes. Hold down the right bracket key and go all the way up to a 999-pixel brush. Paint away the parts of the image you do not want to see darkened. Check your work periodically to make sure everything has been erased that needs to be erased. Do this by turning off the eye icon next to the background layer in the Layers palette to reveal the parts the Mask has covered up.

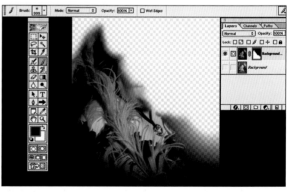

Step 6

Select the Lasso tool and draw a circle around the shadowed part of the woman's

cheek. Make sure the Feather Radius on the Lasso tool is set to 20.

Step 7

Copy and paste the cheek into its own layer (Command/Control + J). Click on the New Layer Mask icon at the bottom of the Layers palette.

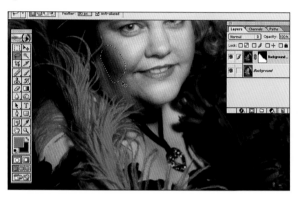

Step 8

Move the shadowed area over the one remaining dimple to remove it. Paint on the layer mask with black as the foreground color to cover the part of the layer that appears to create a pattern and save your work.

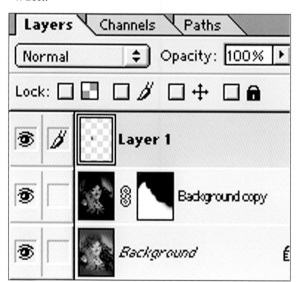

Step 9

Now that you have improved the shadow detail with this woman's own skin to create a natural look, we will add just a few finishing touches to finalize this project. The correction we made to the shadow area created green-looking skin that needs to be changed to flesh color. Activate the background copy in the Layers palette. Then, select the Paintbrush tool and click on the Airbrush option. In the Options bar, choose the Color mode, 20% Opacity and 10% Flow.

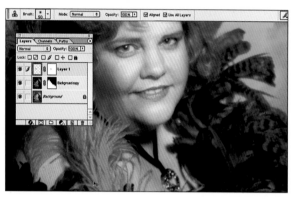

Step 10

Press Opt/Alt to transform the Airbrush into an Eyedropper, allowing color sampling. Click on the pink cheek area to sample that color. This will instantly set that tone as the foreground color. Release the Opt/Alt to paint over the green skin, being careful to avoid the red feathers. The Color mode is great because it allows the translucence of the original skin to shine through.

Step 11

Using the Color Range selection tool, create two new layers of feathers. Sample the red feathers (and make sure you only get the feathers). Click OK, then copy and paste the selection into its own layer by pressing Command/Control + J. Then go to Edit> Transform>Flip Horizontal to move the feather layer into a harmonious position with the rest of the feathers. Then press Command/Control + T. Hold the cursor outside the Transform bounding box to bring up a two-headed-arrow cursor. With this, you can rotate the feathers so that they match up smoothly. Once they are matched, press Enter.

Step 12

At this this time flatten the existing image to make your file size more manageable. If you want to preserve all the stages, save a copy with all the layers.

▷ ILLUMINATING SHADOWS

Example 1—Portrait. After completing the shadowing techniques on the chin and cheek area, the area under the eyes still needs to be lightened.

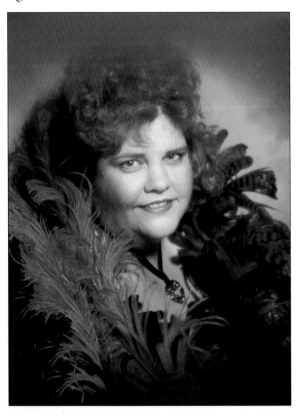

Step 1

Duplicate the background layer and create a new layer mask. To do this, go to the Layers palette and hold down the Opt/Alt key while you click on the Duplicate Layer icon at the bottom of the palette. A dialogue box appears. Set the Mode to Soft Light, and click on the Fill with Soft-Light-Neutral Color (50%Gray) check box, and click OK.

Step 2

Magnify the picture using the Zoom tool. With the Zoom tool selected, click and drag over the area of the image with the woman's eyes to view them up close.

Step 3

Select a brush that is approximately the size (vertical width) of the dark areas under the eyes.

Step 4

Select the Airbrush tool and set the opacity to 20%, and the Mode to Normal. Go to Window>Show Swatches and select a light gray color (10% gray—the second gray swatch over from the left). Now, the dark area can be painted away instantly.

Step 5

Do one eye at a time, starting with the left eye.

Step 6

Move to the right eye, and complete the same process.

You can also choose a dark color to finish off the shadows from the last exercise. I applied the Dust & Scratches filter to this image to blend the pores of the skin (refer to the earlier section on the Noise filter for the steps of this process). Now flatten the image.

Step 7

To completely finish this image, go to the gap near the part in her hair and select it with the Lasso tool using a Feather Radius of 20 pixels. Select the hair just to the right of the part. Now copy and paste it to its own layer (Command/Control + J). Use the Transform tool to make it fit perfectly into the hair that is already there. Adjust the layer opacity to further blend the layer. (You can also use the process you learned with layer masks to fine-tune your layer.)

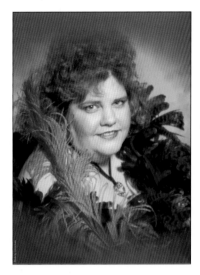

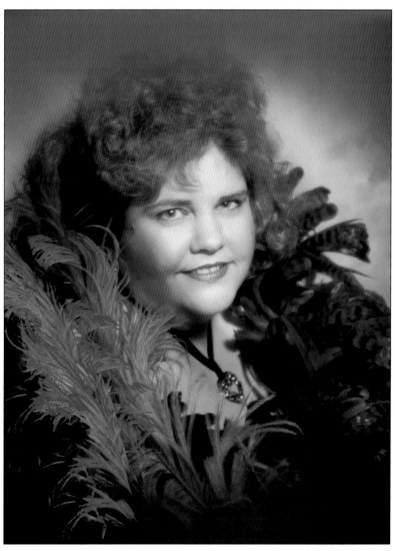

Before enhancement (above) and after (right).

Example 2—Bride and Groom. We will significantly lighten the shadows in this portrait of a bride and groom, using some of the same techniques previously used in the section on dodging, burning, channels and replacing color.

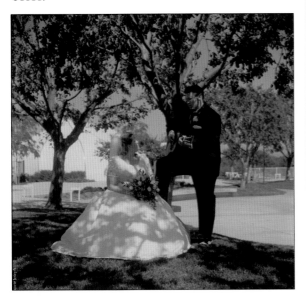

Step 1

First, duplicate the background layer twice. Click on the middle background layer copy to activate it.

Step 2

Double-click on the name of the middle layer in the Layers palette, and rename this layer "Bride and Groom."

Step 3

Use the Magnetic Lasso tool to select the bride's dress. Set the Feather to 0 and check the Anti-Alias box. Set the Width to 10 pixels, the Edge Contrast to 80% and the Frequency to 30. Outline the white dress without concern for perfect accuracy.

Step 4

Go to Select>Color Range. Click once in the shadow part of the dress, then move to the

"+" Eyedropper and click in the highlight part of the dress. Continue to click with the "+" Eyedropper until all of the dress is selected. Click OK.

Step 5

To alter the selection in the Quick Mask mode press Q or click on the Quick Mask icon. You are returning to this now familiar method in order to select only the dress and subtract the white roses from it. When the perfect selection has been created, return to the Standard mode (or use the keyboard shortcut by pressing Q). Go to Selection> Save Selection. Name the channel "Dress," and click OK.

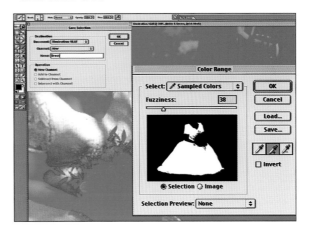

Step 6

With the selection active, go to the Layers palette and click on the Layer Mask icon at

the bottom of the palette. This action displays the white dress as the only part of the layer that is available for you to work on. The marching ants have been transformed into a layer mask.

Step 7

Now go to Image>Adjust>Replace Color. This time, click on the shadow. Either hold down the Shift key and continue to click on the shadow pattern on the dress until it is all uniformly white (with no pattern left), or click on the "+" Eyedropper tool and continue sampling the image until it becomes a uniform white.

Step 8

Click on the "Bride and Groom" layer, then use the History Brush to brush detail back into the lace part of the dress. Use the Patch tool to smooth out the shadow on the dress by circling the highlighted area and simply moving the tool over the shadow area, creating a blending effect.

Step 9

Click on the "Bride and Groom" layer and zoom in on the groom's face. Continue using the Patch tool, then move on to the Healing Brush. Select a 5 pixel soft brush and begin removing the shadow by pressing Option and clicking on the portion of the skin that you want to change. The Healing Brush is used like the Clone tool, with one great difference: the blending from the source to the new location is perfect—unless you get it too close to the shadow of the hair or eyes. It is important to avoid those areas.

Step 10

Do some finishing touches with the Clone tool, but make sure you are on the Lighten then the Darken modes (to make a smoother transition). This tool can be used to tone down the dark shadows that were not sufficiently improved on the groom's face. When you are done, flatten the image and remove the extra channel you created.

Step 11

A little noise can be added to the groom's face in the area where the shadow was toned down. To do this, go to Filter>Noise>Add Noise. Enter 1.5% and select Gaussian, then click OK. In the History palette, take a snapshot of the Noise state, then click in the empty box next to the snapshot. In your toolbox, click on the History Brush, and set it to about 30% Opacity and 20% Flow. Paint on the Noise over the areas where the Clone tool, Healing tool and Patch tool made the skin too smooth.

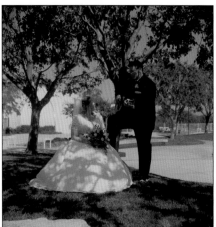

Before enhancement (above) and after (left).

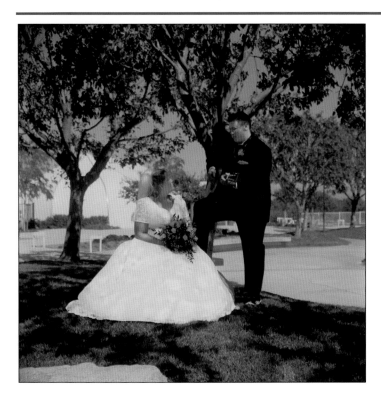

Example 3—Mount Rushmore For a third example of illuminating shadows, let's look at a photo taken at Mount Rushmore. The photographer bracketed his exposure to come up with eight images, out of which two will be used: one with a brilliant sunset, and one with the perfect detail of the presidents carved into the mountain. In just a few simple steps, both images will be merged together to produce a single, beautiful photograph.

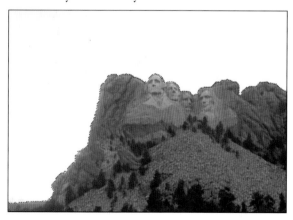

Step 1

In the tool box, select the Magic Wand tool. Set the Tolerance to 50 and the check Anti-Alias box to activate it. Using the Magic Wand tool, click on the white sky in the background the image. Because of the high contrast of white against the mountain, the entire sky is instantly selected.

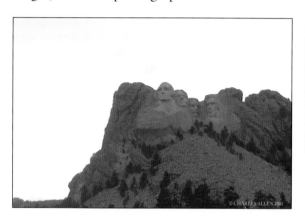

Step 2

Moving to the exposure with the sunset, use the Magic Wand tool (with the same settings as noted in step 1) to click on the silhouetted section of the mountain. Save this selection (Select>Save Selection), and name it "Mt Rushmore."

Step 3

Go back to the image with the white sky and press Command/Control + I to inverse the selection. Save the selection (Select>Save Selection), and name it "Perfect Mt. Rushmore." Copy your selection to the clipboard by pressing Command/Control + C.

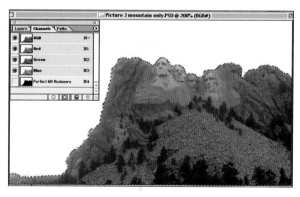

Step 4

Now return to the beautiful sunset image and go to Edit>Paste Into.

You will notice the Layers palette now has a new layer with a layer mask in place.

Step 5

This job is now complete. Flatten the image and save it.

There are a few things to keep in mind when completing a job like this one. First, the project must begin with the desired end in mind—when the photographs are being taken. If the photographer had not taken at least ten bracketed exposures of this scene on a tripod to insure the placement of the desired subject, this task could have been a nightmare. It helps to have excellent photographic skills, and the foresight to plan ahead.

Final image composited from two exposures.

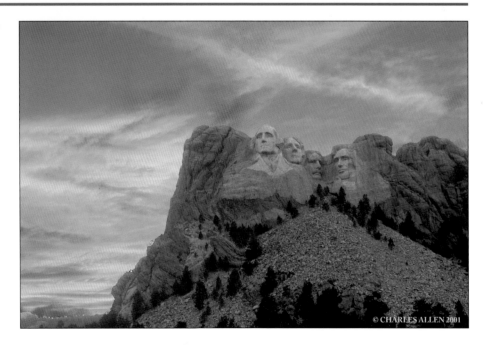

▷ GRADIENT SHADOWS

The original job was to take the distractions out of the background of the image of this fine Arabian show horse. Then, the breeder decided the display needed a different background. The ultimate process will not only involve moving the horse into a different background, but creating a gradient shadow to complete the illusion that the picture was taken in a natural setting. This process brings together a number of methods that have already been covered. Detailed instructions will not be provided in the steps for these previously-illustrated methods.

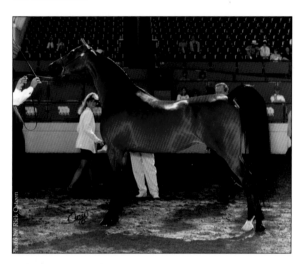

Step 1

Duplicate the background layer to create a background layer copy. In the Layer Properties menu, name this layer "Horse." For this project, use the Extraction method. Go to Image>Extract. Select the animal using the Smart Highlighter. When the Extraction has been completed, click on Preview. It is obvious, when the image is first viewed on the checkerboard, that there is a lot of cleanup work to complete. Choose White Matte from the Extraction dialogue box, then choose Black Matte for the clean up process. Complete the cleanup on the

Black Matte because the horse is to be placed in a black area of a sunrise scene. Because we will be pasting the horse into the image of a sunrise, I have chosen to bring some of the dirt in from the original picture with the horse to provide some natural foundation.

Step 2

Use the Cleanup tool to remove fringe pixels, holding down the Opt/Alt key while using the tool to paint areas back in.

Step 3

When your extraction is perfect, click OK.

Step 4

Open the illustration that is to become the new background for this stallion. If possible, place the two images side by side (or at least have both images available on the screen).

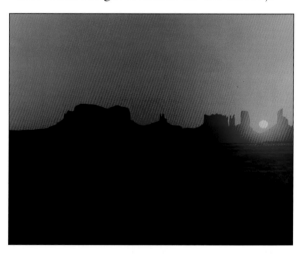

Step 5

Activate the image of the horse by clicking the top layer of the extracted horse image.

Step 6

Select the Move tool, then click and drag the extracted image of the horse into the background image. (I chose the image of the canyon lands area because the photo of the horse was taken with a strobe. I felt like it would blend into the sunset image, and—at that time of day—a flash *would* have had to been used to get the shot.)

Step 7

We want the horse to be facing the sunrise. To do this, go to Edit>Transform>Flip Horizontal.

Step 8

The horse layer has now been placed in the sunrise scene. Click on the dotted circle at the bottom of the Layers palette to create a new layer mask on the horse layer.

Step 9

The next step is to blend the horse into its new background. Click on the layer mask in the horse layer to make it active. Go to the Gradient tool in the tool box (or just press the G key). With black as your foreground color, select Black to Transparent (second box in) in the Gradient options, then click drag the crosshair cursor from the left bottom corner, then from the right bottom corner. Repeat this as many times as it takes to tone down the bright dirt and blend it into the black.

Step 10

We will be using the Lighting Effects filter to create shadows (rather than light) in this step. Go to Filters>Render>Lighting Effects. Under Style, select Default. For Light Type, select Spotlight and check the "On" box. To the right of the intensity slider, click to activate the Color Picker and select gold as the color. Set the Intensity to 35 (Full) and the Focus to 69 (wide). Under Properties, choose: Gloss=0; Material=69 (Metallic); Exposure=0; Ambience=8 (Positive). Set the Texture Channel to None.

Step 11

Go to the History palette, and click on the Create New Snapshot icon at the bottom of the palette. Go to the top of the History palette, double-click on the new snapshot you just created, and name it "Lighting Effects." In the History palette, make sure the History Brush Source icon has been placed in the spot next to the Lighting Effects history snapshot. Activate the history state right before Lighting Effects.

Step 12

Click on the History Brush in the tool box and set the opacity to 50%. Select a brush and use it to tone down the shadowing you created in the Lighting Effects—so it presents the effect of the filter in a more subtle manner.

Step 13

One final task remains for this photo to be correct: the bridle must be removed. This can be accomplished using a combination of layering, selections the Clone tool and the Healing Brush.

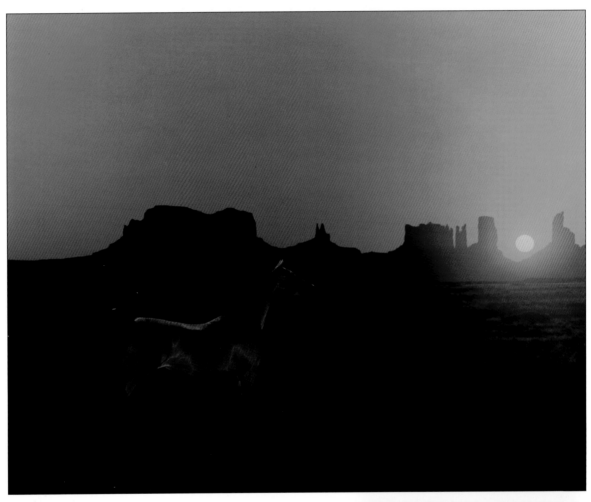

Before enhancement (right) and after (above).

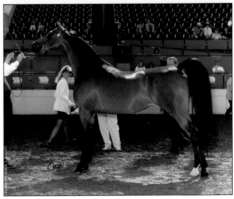

Restoring Old Photos

Most pictures that come to the retouching and restoration artist that are truly family heirloom pictures are either black & white, brown-tone, or a oils-and-pastels combination. Regardless of how old these images are, they are likely to be in poor condition and in need of significant work. The customer is bringing this picture to a professional to get it repaired. When working with old pictures it is important to keep in mind that these images are treasures to their owners—even if they are brought in to you in pieces!

The photo shown to the left is typical of images presented for restoration work. This work requires a significant investment of time. (Once you are over the initial shock of this image, it reminds us why so many people still can't "kick the habit" today! This little boy, I can only imagine, was a victim of his era.) In my many years as a photo restoration artist, I have never seen an old photo that was more unique!

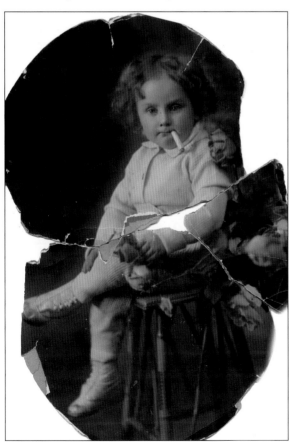

▷ HOW TO REPLACE MISSING PIECES

Step 1

Due to its size, this photo required a tabloid scanner to effectively complete the scan. However, scanning is a necessary first step.

Step 2

Save a copy of the original scan. Note that there are several problems we face with this image. One is that the part that is missing on the image cannot be replaced by copying a part of the other arm.

Step 3

Zoom in on the problem area of the child's left arm.

Step 4

Using the Lasso tool, select an area around the intact white area on the arm.

Step 5

Copy and paste the selected area into its own layer by hitting Command/Control + J.

Step 6

Distort the layer to line up the ribs of the sweater, and click OK. Do this by going to Edit>Transform>Free Transform (or press Command/Control + T).

Step 7

Click on the Layer Mask icon at the bottom of the Layers palette. Line up the ribs of the sweater and click on the White Layer Mask to the right of layer 1. Choose a soft brush to paint out the parts that do not fit.

Step 8

Drag the right side of the sleeve to cover as much of the white hole as possible.

Step 9

For better layer management, name each of the four layers created so far. Beginning with the top layer, hold down the Opt/Alt key and double-click on the sleeve replacement layer. Name it "Sleeve Replacement." Then, return to layer 1, hold down the Opt/Alt key and double-click on this layer. Name it "Boy's Main Body Parts." Go to layer 2 and follow the same procedure, naming it "Top of Head." Move to layer 3 and name it "Left Side." Now you have created some order in your Layers palette.

Step 10

In order to create a new layer set (to further create order in your work), click on the small file folder at the bottom of the Layers palette. A Layer Set dialogue box appears. Name this set "Sleeve Replacement Parts" and color code the set with red. Drag the Sleeve Replacement layer up into the new file fold-

er set. The layer is recessed about a quarter of an inch to let you know the two are combined as one. Now all the layers created to fix this sleeve are in their own set.

Step 11

Circle the cuff with the Lasso tool. In the Layers palette, click on the Sleeve Replacement layer, then paste the selected cuff into its own layer (Command/Control + J). Press the Opt/Alt key and double-click on this new layer. Name it "Cuff." Note that the new Cuff layer is right above the Sleeve Replacement layer within the layer set.

Step 12

Continue to build layers, stretching and transforming them to fit. Smooth out the corrected areas until the sleeve is smooth and complete.

Step 12

To finish this project, you will use all of the skills you have acquired through many hours of practice: dodging with layers, the Dust & Scratches filter, and layer masks, until there are no scratches left and the finished image looks good as new, ready for framing.

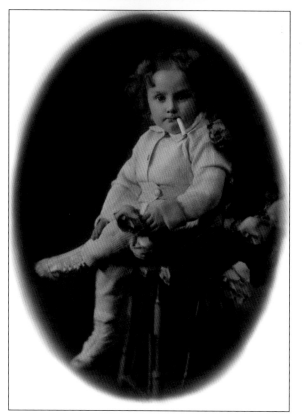

▷ CREATING DUOTONES

We will use the illustration below to demonstrate how to turn this black & white picture into a duotone.

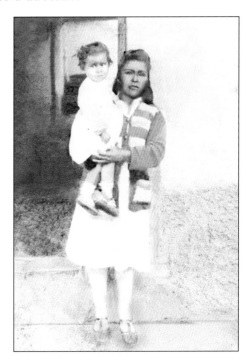

Step 1
Open the grayscale image of a mother holding her baby.

Step 2
Switch the image mode to duotone by going to Image>Mode>Duotone. The Duotone Options dialogue box appears.

Step 3
For Type, select duotone in the pull-down menu. This allows you to apply two inks to the image.

Step 4
Click on the Ink 1 color swatch square, and select black. Then click on the Ink 2 color swatch square, and select Pantone 1365 CVC as the second ink. Click OK. This will

automatically transform the picture to the duotone mode. The photo will now have a sepia tone.

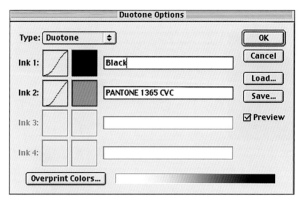

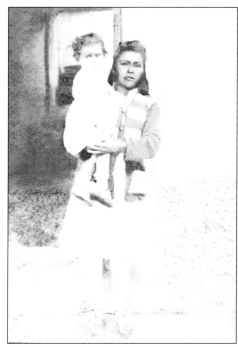

▷ COMBINING COLOR AND BLACK & WHITE PHOTOGRAPHS

This section will demonstrate combining existing color "hand-tinted" originals with a color image of a sunset—all merged together into the black & white image of a World War II battleship with four submarines.

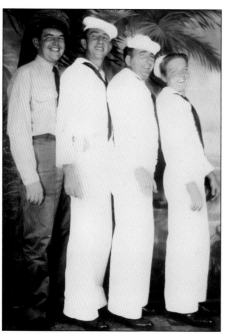

Step 1
Open all three images. I measured carefully and made sure to scan each image in at the appropriate scale so that the parts would all fit together perfectly.

Step 2
Click on the hand-tinted image containing four sailors and select the sailor on the left using a loose selection with the Lasso tool. Set the Feather Radius to 50 pixels.

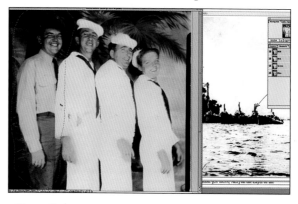

Step 3
Convert the black & white image grayscale to color (Image> Mode>RGB).

Step 4
Drag the image of the sailor into the battleship image.

Step 5
Now you need to name the layer by pressing Opt/Alt and clicking on the layer of the seaman. Name it "Sailor," and click OK.

Step 6
Now click on the sunset photo to make it active, then go to Select>All (or use the keyboard shortcut—Command/Control + A). Copy the selected area by going to Edit>Copy (or use the keyboard shortcut Command/Control + C).

Step 7

Go back to the battleship image and click on the sky behind the ship with the Magic Wand tool (with the Tolerance set to 50). Make sure your selection is perfect.

Step 8

Press Command/Control + Shift + V to paste the sunset into the battleship image behind the sailor.

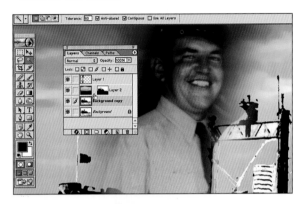

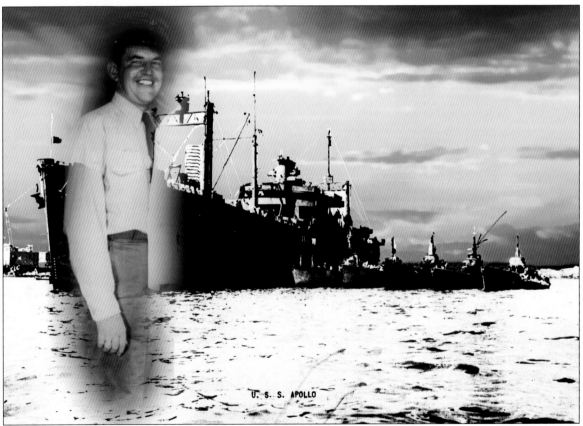

▷ VARIATIONS

Variations is a pull-down menu item that is very helpful in the process of comparing colors. For this image of a toddler in a field of flowers, the customer requested what she described as a golden tone.

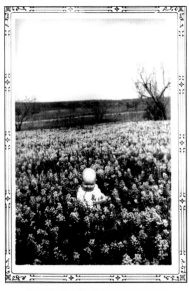

Step 1
Open Variations by going to Image>Adjust>Variations.

Step 2
Once the dialogue box is open, experiment with various combinations of settings.

Step 3
Choose More Red and More Yellow to produce the look of a sepia-toned image (making it almost golden in color) and select OK. You need to work in the highlight, shadow, and midtone areas and view them at settings from Fine all the way to Coarse. If you choose a setting where colors look psychedelic, the image will not print; this image already has as much of that color as it can use. In other words, do not choose the out-of-gamut colors if you intend to print this photo.

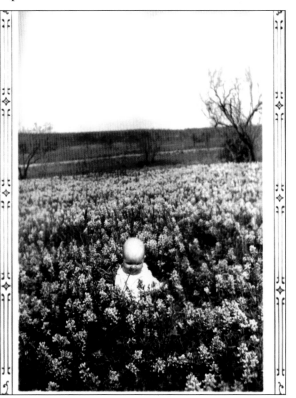

▷ IMPORTING SKIN TONE

There are two basic ways to get realistic skin tones onto black-and-white images. The first is to use the Color Picker and select out a flesh tone. The second method is the one I prefer: click with the eyedropper on a color photograph with similar skin tone.

Step 1
Open both images.

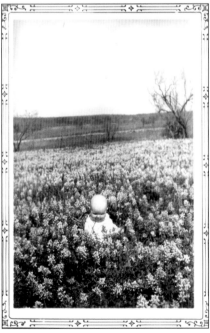

Step 2
Choose the Paintbrush with the Airbrush option. In the Options bar, set the Opacity and Flow to 20%. Set the Mode to Color.

Step 3
Click on the color image to make it active.

Step 4
Choose a large, soft brush.

Step 5
Press Opt/Alt and click on a light area of skin on the cheek of the subject in the color image.

Step 6
Move back to the picture of the little girl standing in the flowers and begin painting freely over the skin areas on the subject. Zoom in as necessary. When you want to intensify the color being painted (for example, in the shadow areas), paint over the same

area more than once. For areas of different color, such as the lips, another color can be selected from the Color Picker. This is all that is required! As I have stated before, the Color layer mode does not do anything but color the pixels. The image data remains the same. In this case the old photo has blown-out highlights on the head, and the color mode will not change the data or reduce the highlights.

Step 7

I was asked to do one more thing by this client. She wanted the flowers to be colored. This a simple task! Use the Rectangular Marquee tool to select from the horizon down (do not select the white border). Then, go to Select>Color Range and click on a flower to select all of the light areas. The only problem with this selection is that it also includes the little girl. To correct this, I simply went to the Quick Mask mode and painted in the little girl and her dress, eliminating these areas from the selection.

Step 8

Photoshop offers a new easy way of adding just one color to an RGB image. Click on the Create-New-Adjustment-Layer icon at the bottom of the Layers palette. Choose Color Mixer from the pop-up menu. The client wanted purplish-pink flowers. To create this effect, go to the Green source channel (mak-

ing sure your Preview box is checked), and choose: Red=-21, Green=113, Blue=0, and Constant=0. Then click on the blue source channel and choose: Red=+30, Green=0, and Blue=+98. Once you have entered these settings, click OK.

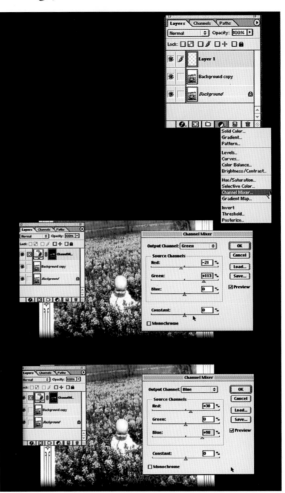

Step 9

The Color Mixer adjustment layer you created to colorize the flowers also features a built-in mask that removes any color that might have spilled over onto the child. Paint on this mask with black as your foreground color, and watch the imperfections melting away.

The final, completed version of this portrait is shown on the next page.

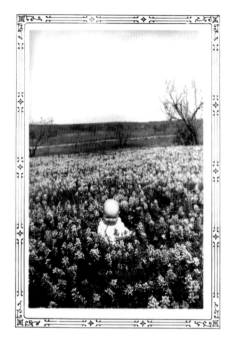

Before enhancement (above) and after (right).

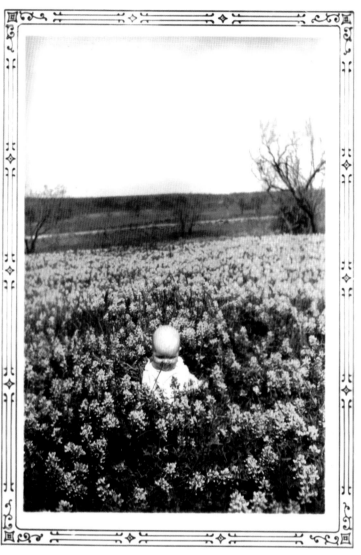

▷ TRUE SEPIA TONE EFFECTS

The purpose in this process is to sharpen the features of the subjects in the image by creating a Mask of the highlighted areas.

Step 1

Convert the grayscale image to color (Image>Mode>RGB Color).

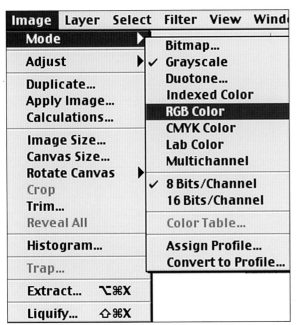

Step 2

Create a new layer by going to the Layers palette pull-down menu. Set its Mode to Color.

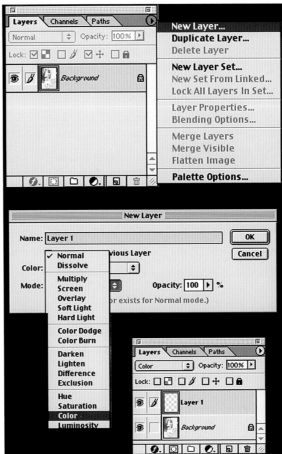

Step 3

Click on the foreground color swatch in the tool box. In the Color Picker, set the following values: H=25, S=60, and B=33. This will

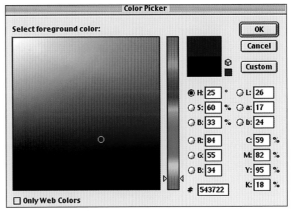

produce a brown shade. You can experiment with other settings to see the impact of these color selections on your final image.

Step 4

Hold down Opt/Alt and click on the new layer in your Layers palette. Name it "Color" in the Layer Properties dialogue box.

Step 5

Press Opt/Alt + Delete to fill the selected layer with the color you have chosen. You will now have an image with a sepia-toned effect.

Step 6

Go to Calculations (Image>Calculations). This brings up a Calculations dialogue box.

Step 7

Under Source 1, the layer setting should read Merged, and the Channel setting should read Gray. Source 2 should also read Gray in the Channel setting. Blending should be set at Normal, and Opacity to 100%. The result will be a new channel.

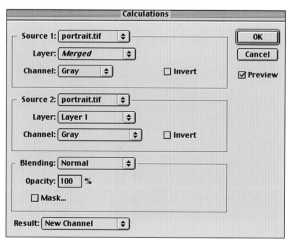

Step 8

Go to Select>Load Selection. This brings up a Load Selection dialogue box. Click OK.

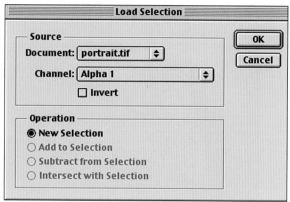

Step 9

Press Command/Control + L to bring up the Levels dialogue box.

Step 10

Under Input Levels, move the black slider to the right, and the white slider just a little to

the left to pull out the highlights on the channel colors. Click OK.

Step 11
At the top of the Channels palette, click on the composite RGB channel.

Step 12
Desaturate the image area (Image>Adjust> Desaturate).

Step 13
Merge these layers by pressing Command/ Control + E, and save your work.

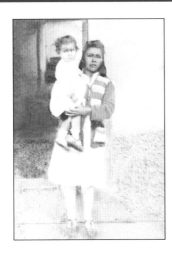

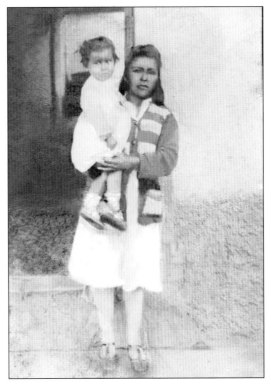

Before enhancement (above) and after (right).

► 7

Advanced Retouching

While you should be relatively familiar with basic operations that have been covered in previous sections, the following advanced techniques do not assume the user has advanced skills.

▷ REMOVING BACKGROUNDS

The photograph below is cute, but the background needs to be removed so that you can focus on the cat. There is a quick solution to the problem.

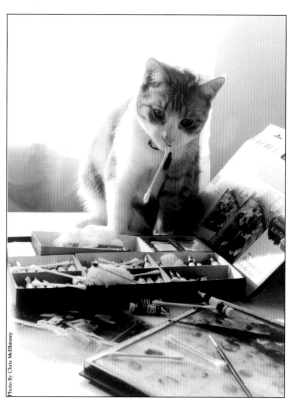

Photo By: Chris McElhaney

Step 1

Open the image in Photoshop.

Step 2

Open the Layers palette (Window>Show Layers).

Step 3

Make a copy of the background layer by dragging it onto the Duplicate Layer icon at the bottom of the Layers palette.

Step 4

The Extract allows you to isolate a foreground object and erase its background on a layer. To begin, go to Image>Adjust>Extract (or hit Command/Control + Opt/Alt + X). Select the Highlight tool (make sure Smart Highlight is not checked) and draw a line that marks the edges of the object. Then you can preview the extraction and redo it or touch up the result as needed. To refine your selection, you can toggle back and forth between the Highlighter and Eraser by simply pressing letter "B" for Highlighter and "E" for Eraser.

If any part of the selection requires the Smart Highlighter, just hold down the Command/Control key while highlighting the subject (I used this when it came to the box of oils). While using the Smart Highlighter tool, you

can switch to the Eraser by holding down the Opt/Alt key.

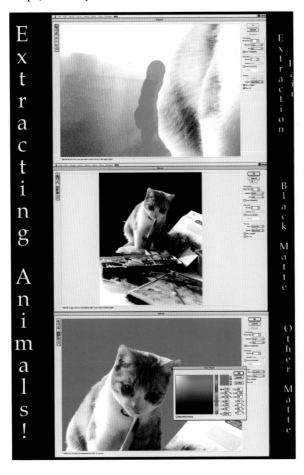

Step 5

Click on the black arrow at the top right of the Gradient tool box and pick Special Effects gradient. Hit Return. Choose white to blue to black.

Step 6

In order to blend the fur more fully with the background it is important to take three steps. First, in the Layers palette, press Opt/Alt and click on the line separating the cat layer from the gradient layer. Then do the same thing with the gradient layer and the background layer.

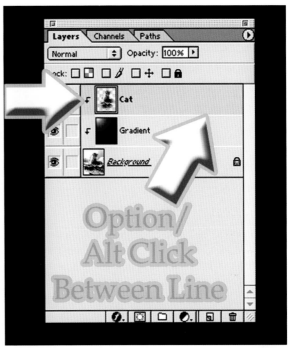

Next, double-click on the cat layer. This will open up the advanced blending methods dialogue box. In this box, under Blend if Gray, check Blend Clipped Layers as Group.

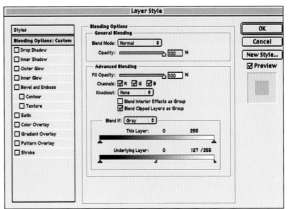

Then, press Opt/Alt and click on the Underlying Layer white slider. What this does is separate the white pixels in the underlying layer, causing them to blend more effectively. Click OK.

Step 7

Now, go to the Elliptical Marquee tool in the tool box. Set the Feather Radius to 180 pixels, then click and drag around the cat. Press Command/Control + Shift + I to inverse your selection. With black as your foreground color, hit the Delete key.

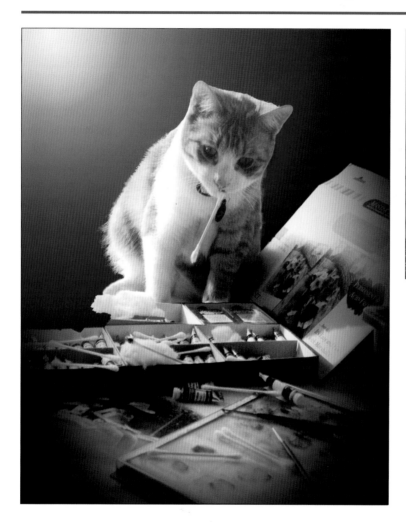

Before enhancement (above) and after (left).

▷ ADDING A PERSON TO THE PICTURE

The task for this image is to add the missing brother to the photograph of a family group. Begin by opening the photos of the family and the missing brother.

Step 1

In the family portrait, drag the background layer to the New Layer icon at the bottom of the Layers palette.

Step 2

Go to View>Show Rulers. Click on the top ruler and drag a guide down from it, placing the guide on the ¾" mark. We are adding space to the background to provide room for the new person to be pasted into.

Step 3

Select the Magnetic Lasso tool.

Step 4

Using the Magnetic Lasso Tool, select the area to the left of the woman on the left, including the entire left-hand side of the image from top to bottom and to the far left edge of the frame.

Step 5

Go to the picture of the brother standing alone. Select this entire image (Select>All), then copy this image to the clipboard (Command/Control + C).

Step 6

Paste this image into the family group. (Edit>Paste Into). (This process will paste the image of the brother into its own layer with a layer mask next to it in the Layers palette.)

Step 7

As you can see in the screen shot above, this brother's image is proportionally larger than the other subjects in the family picture. To ensure that the height of the man in the cowboy hat is correct, it is important to measure his height with a guide. Place the cursor within the horizontal ruler and click drag a guide into the photo. Align this guide a third of the way down the forehead of the man (in the family photograph) to the right of the man in the cowboy hat.

Step 8

Press Command/Control + T to create a transformation bounding box around the brother with the cowboy hat. Then, hold down the Shift key while dragging one of the corner anchor points with the cursor. Drag the anchor point inward toward the center of the image until the brother's size is propor-

SAVING RAM (PURGING THE CLIPBOARD)

Memory is always an important consideration when using Photoshop. There is nothing more frustrating than having a message pop up telling you there is insufficient memory to perform the operation, save your work, etc. Purging the clipboard can free up room. This is an easy way to maintain usable RAM for the operation of Photoshop. Purging the Histories can free up room as well. A simple way to purge both at the same time is to go to Edit>Purge>All. When you receive the warning regarding the results of this command, consider it seriously before you click OK.

tional to the size of the other subjects in the family photo. (Be sure to hold the Shift key down until the operation is complete.) Line up the top of the brother's forehead with the guide. (*Note*: Since the brother is wearing a hat, you will have to use your best judgement.)

(*Note*: Photoshop 7 made a vast improvement in this process. The anchor points no longer rest outside of the image area.)

Step 9

There is a line that exists between the two backgrounds that makes it obvious that the image has been retouched. To correct this, Paint on the layer mask with black as an eraser and white as painting in—with the opacity set to 100. Select a large soft brush for the background. When appropriate blending has been achieved and the picture appears natural, flatten the image.

Before compositing (right), and after (above).

▶ 8

Commercial Techniques

▷ CORRECTING PERSPECTIVE

For years, commercial photographers have been using view cameras with swing and tilt features to correct the distortion caused in a subject's vertical lines. Photoshop 6 has a great new Cropping tool that can correct this perspective problem in a one-step process.

Step 1
Open the image to be transformed. (The image shown above has a perspective problem needing correction.)

Step 2
Select the Cropping tool, then click and drag over the entire perimeter of the image. Then, release the mouse button.

Step 3
Check the Perspective option in the Cropping tool Options bar. Then move the corner handles until the lines of the cropping indicator are parallel to the lines you want to make vertical.

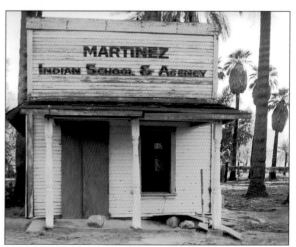

▷ 3-D TRANSFORMATION

Our task is to transform this image into a 3D image. With the 3D Transform filter in Photoshop, 3D images can easily be created in ways never before possible. We will begin the task using the image below.

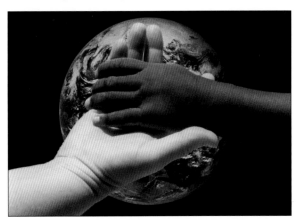

Step 1

Open the image to be transformed. Go to Filter>Render>3D Transform.

A 3D Trans-formation dialogue box will appear with a grayscale image of your original photograph.

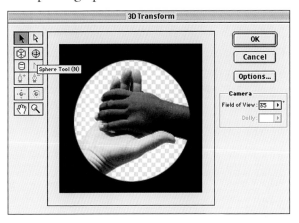

Step 2

Select the Sphere Tool (located just below the white arrow). This Tool will produce a cursor in the form of a "+". Drag the + (cursor) into the grayscale image and click drag, forming a green circle.

Step 3

If the green circle is not precisely where you want it, click on the Direct Selection tool (the white arrow) and place it over the green outline of the circle. Then, position the circle as you like. If the circle is not large enough, go to one of the two the Anchor Points (located along the the green circle), then click drag until the subject is outlined in green. Release the mouse button.

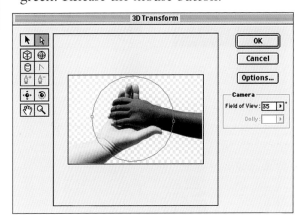

Step 4

In order to obtain a high quality output, it is important to select the High setting in both the Resolution (Options>Resolution) and Anti-Aliased areas. Make sure that the Display Background option is not checked to form a black background.

Step 5

In the 3D Transformation dialogue box, choose the Field of View setting, and experiment with the settings.

Step 6

Click on the Dolly setting. This setting increases or decreases the size of the image while suspending it in space. Again, experiment to choose your settings.

Step 7

Move to the Trackball tool and click on it. This tool allows you to manipulate and change the perspective of the selected image, changing angles or rotating it. Play around with the Trackball to explore the possible settings. When you find the settings you like, click OK. This renders the transformation.

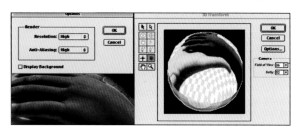

Step 8

In order to get rid of the white globe effect, click on the Layer Mask icon at the bottom of the Layers palette. In the tool box, select the Paintbrush tool, and set black as the foreground color. Choose a soft brush and start painting on the image to remove the unwanted part. You will notice this acts as an eraser, allowing the Earth on the background layer to shine through. Feather the white hand to blend into the earth. This action completes the process. Save the image by clicking OK.

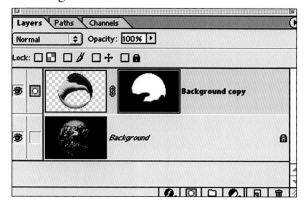

In this example, we have only explored the rotation of a sphere. The same process can also be used with a cube or a cylinder. Experiment and explore the many possibilities available to you.

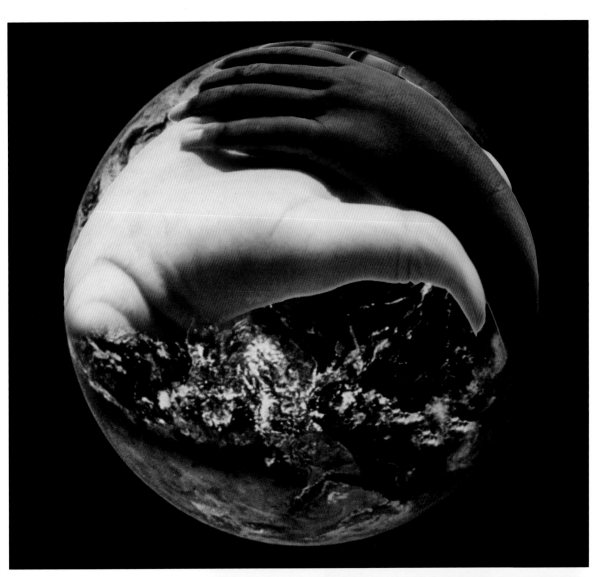

Original image (right),
final image with 3-D effect
(above).

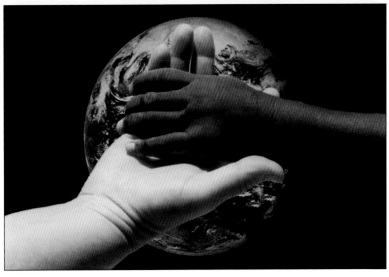

▷ VIGNETTING

Vignetting enhances an image by placing the focus of attention on the subject. A vignette can be any color you choose. Black and white are the colors more traditionally used in photography. Let's add a vignette to the 3D transformation photograph we just completed.

Step 1

Vignetting is a simple process. Begin by selecting an object, set the feather radius, and press the Vignette action in the Actions palette.

Step 2

In the tool box, select the Elliptical Marquee tool. In the options bar, check the Anti-Aliased Selection and set the feather radius to 50 pixels.

Step 3

Make the selection by choosing a starting point in the upper left corner, then clicking and pulling the cursor down to the right corner until you have a centered elliptical selection of the desired size.

Step 4

Once the selection outline is developed, click on the Actions palette and Select Vignette by clicking on it. When selected it becomes highlighted.

Step 5

Press the Play button at the bottom of the Actions palette. It turns red to indicate that it is playing. The action automatically brings up a feather radius dialogue box. Set the feather radius to 150, and click OK. This action produces a beautiful white vignette on your image.

Before vignette (above),
and after (right).

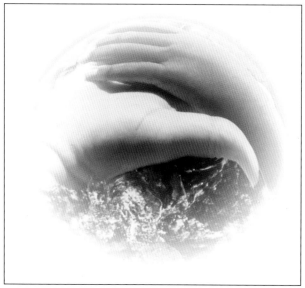

Image Output

After you have completed all of the desired retouching and/or restoration processes on an image, it is important to know how to obtain the highest possible quality output for your finished product.

► PRINTERS

My concern in printing has always been threefold: quality reproduction, photographic longevity, and affordable price. These issues will be addressed as we consider the various concerns in seeking the appropriate equipment to provide the output you desire and need in order to meet your customer's expectations. The type of printers considered in this chapter are computer-driven ones—regardless of size or cost.

Reproduction. The print quality of a printer is usually rated in terms of resolution. The higher the resolution (dpi), the finer the images appear.

Print-Out Longevity. Longevity is the ability to print out a photographic quality print on a computer-driven printer that will last just as long as a normal color photograph.

When color photographs first came into existence the color would begin to fade away in about five to ten years. As film manufacturers worked to resolve this problem, they extended the life of color prints to twenty to fifty years. We now find that history is repeating itself in digital photographic printing, where prints are also becoming longer lasting. Keep in mind that digital print longevity estimates, as reported by salespeople, is in incandescent lighting, not direct sunlight.

Print longevity varies based on the type of printer used to output the image, In ink-jet printing, the biggest challenge to longevity lies in the type of inks available for the printer. Color laser printers have even less longevity. In contrast, dye-sub printers output images that will last approximately twenty years. Some ink-jet printers are now addressing this problem,

COLOR

I had a wonderful experience many years ago when attending a Kodak retouching workshop. They demonstrated how a pure white light, when passed through a prism, appears to the receptors in the eye to break down into primary colors. When primary-colored lights are combined together, they produce a pure white light. In order to see color on an object, light must strike colored pigments, such as those in paints and dyes, and reflect it back into our eyes in order for us to "see" it. The combination of the color of light striking an object and reflecting back into our eyes is the color we perceive.

however, and manufacturers are producing inks that maintain their quality for extended time periods.

Labs can also produce a photographic prints from digital files, maintaining photographic quality equal to a print made from a negative. Some lab printers are Kodak LED printers, which can produce prints up to 20" x 30" prints from a 300dpi [at 20" x 30"] digital file. The FUJIX® Pictography® 3500 and 4000 printers produced by Fuji offer other options. The maximum size produced by a 3500 is an 8.59" x 11.77" at 400dpi. This printer completes the task in a single-step operation that uses a laser diode exposure and thermal dye transfer with a three component color process: yellow, magenta and cyan. The 4000 uses a four-step printing process of photochemical and laser technologies that produces a photorealistic digital color print. The maximum size of images for this model is approximately 12" x 18". The prints are guaranteed to last for fifty years.

It is important to check with your local lab to determine the type of services they offer for digital prints, and the expected longevity with the various processes.

▷ GOOD PRINTERS YOU CAN AFFORD

There are many good printers on the market today that provide you with photographic-quality output. While Epson seems to be the leader in this industry, there are other manufacturers whose products produce a high quality photographic output—Hewlett Packard®, Cannon®, and Lexmark® are among the most familiar.

Before we continue, it is important to be aware of some key principles regarding printers. First, a manufacturer's claim that a printer produces photo-quality prints does not necessarily equate to true photographic-quality output. While the printer may provide a "photographic print" that is acceptable for a family scrapbook, it may not be able to produce the commercial-quality photographs that are necessary to provide a finished product that meets your customer's expectations. These lower-end printers may, however, provide acceptable output for proofs. A rule of thumb: if you want a high-quality print, select a printer that uses a six-color ink cartridge, rather than three in addition to the black cartridge.

Epson Printers. Let's first look at the Epson printers. Epson markets the following ink-jet models as providing photographic quality prints: the Stylus Photo 780, the Stylus Photo 1280, and the Stylus Photo 2000P. Epson is truly pushing the ink-jet printer market further than I thought was possible.

While the selection is varied, and any of the listed printers may provide an adequate output for you, the factors to be concerned about in addition to quality are: speed of output, and print size desired.

The Photo 780 will provide 8.5" x 44" outputs at 2880 x 720dpi. The Photo 1280 provides up to 13" x 19" prints at 2880 x 720 dpi. The 2000P provides 13" x 44" output size at 1440 x 720dpi with pigmented inks. The Stylus Pro 7000, 7500 and 9500 models will produce sizes up to 22" x 43.3", and provides six-color ink-jet printing. These models provide 1440 x 720dpi photo-quality color printing.

These photo-quality Epson printers are capable of producing quality, border-free photos. The pigmented inks in the Photo 2000P contain dyes that now provide extended photographic longevity. The prices vary for the differing models, and change from month to month.

Hewlett-Packard Printers. Hewlett-Packard is a well-known manufacturer of quality laser jet printers. They have an excellent, affordable, photo-quality printer, the Photosmart® 1218 model. This printer is a fast, six-color model that prints a maximum size of 8.5" x 11" at 2400 x 1280dpi.

Cannon Printers. Cannon offers one recommended printer that produces photo-quality prints at a reasonable price. This is the S800 model, which outputs up to 8.5" x 11" prints at 2400 x 1200dpi using a system that employs thirteen color inks and two black inks.

Dye-Sub Printers. The value of using a dye-sub printer is that its prints have greater longevity, as compared to those from ink-jet printers. The dye-sub printer uses a color ribbon to produce the final product, but operates at a slower printing rate. The prints that come from such a printer are brilliant!

Dye-sublimation printers use a process that involves the printing head heating the dyes until they sublimate. Once they have become gaseous in form, the inks penetrate the paper's special coating. The printer must have an additional "long-life ribbon" in place to ensure longevity of the color.

This type of printer can be used to provide the customer a final printout of high quality—except for larger color prints (at this time). While other printers provide good proof pictures, the dye-sub printer produces true photo-quality prints that will last at least twenty years. If you will be providing a number of final prints on an ongoing basis for your customers, this printer would be a worthwhile investment, in addition to an ink-jet printer to provide you with proofs.

Kodak and Olympus are currently the primary manufacturers of the dye-sublimation printer, but these printers tend to be expensive (about $5,000). As an example, Kodak pro-

OUTPUT TO A DYE-SUBLIMATION PRINTER

One of the major advantages of the dye-sub printer is that it provides a high quality print that color-matches in an almost perfect manner. In other words, the hues are more life-like, providing blacks that are black, a full scale of shades of gray, and colors that radiate a brilliance. A dye-sub printer can print an image that is saved at 300 dpi in the RGB mode, and requires no additional special preparation. While these printers are more readily available now than ever before, and at an affordable price, they still remain more expensive than ink-jet printers.

duces a dye-sublimation printer called the 8670 model. It is a very good and very fast printer, printing up to 8.5" x 14" prints, but tends to be expensive. Kodak, however, produces a printer (the ML-500) that creates a print in 13 seconds at a cost of only ninety cents.

I have experience with the output of the Olympus P400 printer, which provides an adequate quality output for restored black & white photographs and color prints that are 8" x 10" and smaller. The machine is fast (it prints an 8"x 10" photo in ninety seconds) and is reasonably priced. It can also print directly from your digital camera, so it does not *require* connection to a computer. This printer sells for about $1,000.

▷ PROJECTS YOU CAN PRINT AT HOME

If you own a dye-sub printer (or other high-quality output printer), you can print anything

within the capability of your printer—though an 8" x 10" is the normal maximum. With attention to quality, acceptable photographs can be printed on a computer-based printer. The exception to this rule is when you plan to order a large quantity of prints of the same image—then, it is better to send it to a lab. However, with rapid improvements in quality and speed, it is hard to know what the future will bring!

▷ FILM RECORDERS

A film recorder is a device that creates a negative from your digital file. To obtain this service you must normally seek out a color lab (now more commonly known as an "imaging lab") that has the capability to perform this task. An increasing number of labs are expanding their services to provide this, but the equipment is very expensive.

Requirements. What you choose for the final image output depends on the type of negative size you choose. If the customer wants the final print to be a smaller image size (up to 8" x 10"), a 35mm negative can be requested. The basic principle is to maintain the quality of product you desire, while getting it at the most reasonable price. A larger negative is not required for an 8" x 10" or smaller photo.

Imaging labs can also produce transparencies. To obtain a quality transparency, the finished digital image should be saved in a 4800 x 4800 ppi format.

▷ COLOR MANAGEMENT
SYSTEM PREFERENCES

Color management helps maintain a consistent matching of the image colors seen on the screen to those that are produced by the printer. Devices and programs may individually vary in their ability to reproduce a full range of colors. A Color Management System (CMS) provides a more accurate representation of color consistency from one program or device to another.

Photoshop 6.0.1 has a built-in color management system. The Photoshop color management system is based on the International Color Consortium (ICC) standard for cross-application. The Photoshop Color Management Module (CMM) allows the user to plug into ICC processes, and is an adjustable module that aligns with other color-matching applications. Photoshop's CMM can be changed to match the settings of another application. The computer operating system also specifies a CMM. On the Macintosh system, the CMM is located in Apple® ColorSync® (2.5 or later). On the PC, the CMM is located in the Microsoft ICM 2.0. (You should refer to the Photoshop user's manual to obtain additional information on this subject.)

Color preferences can be set up to match the demands of whatever printing device is being used. Again, the procedures are found in the Photoshop user's manual and need not be duplicated here. Just a reminder: it is always important to calibrate your monitor after installing Photoshop and before using the program. This is normally a one-time process, unless Photoshop is reinstalled. The procedures for accomplishing this task are also detailed in the user's manual.

Windows-based computer users I have worked with have had difficulty matching color output to on-screen colors. Color corrections can be fine-tuned more fully with color correction software. As an example, Pantone® Color Correction is suggested for use with Windows, and many individuals find

it to be effective. On the Macintosh computer, I find that the Macintosh ColorSync is highly effective in providing consistent output if set up to match the printing device.

The Adobe® Gamma Module® is a walk-through program that Adobe 6.0.1 has developed to assist you in moving through the process of setting up the CMS.

However, that is just the beginning—and Adobe will tell you that, as well. Calibration devices that fit onto your screen, known as colorimeters, are an absolute *must* to get your color in control. The prices of such devices are reasonable. If you use a process such as this, the program will guide you in a step-by-step manner through the system, question by question, until the CMS is set up specifically for your equipment. This, too, is a one-time process, unless you reinstall Photoshop.

▶ 10

Developing Your Market

▷ SELLING YOURSELF AND YOUR WORK

This chapter is designed primarily for those individuals who are seeking to establish a digital photo-retouching business from scratch. These principles could also be applied by photographers who want to expand their businesses to include digital retouching.

The most important element in any privately-owned business is the marketing of your services. You can never relax your efforts if you are to be successful: always keep an eye open for opportunities to sell yourself and your services, and to make prospective contacts. Normal business processes are important. You must have business cards, you must advertise in various media (depending upon your available financial resources), establish a consistent telephone number and address, and open a business bank account. Don't forget your business and resale licenses. After that, you'll need to look at a plan for developing your market.

▷ THE "THREE-POINT MARKETING PLAN"

The Three-Point Marketing Plan provides you with a structured manner of developing your digital retouching service. To begin with, you are in the market to retouch photographs, so obviously photographers are the most likely candidates to focus on as you begin developing your business.

1. Initiating Contact. To begin this phase of the process, determine the geographic limits of your contact area by how far you are willing to travel. Then go to the yellow pages in your local telephone directory and identify the professional photographers in your area. Decide which are in your geographical limit, recording their names, addresses and telephone numbers. Indicate the contact person if possible. Contact every photo studio and commercial photographer within your predetermined driving distance by telephone. You may need to make as many as 100 telephone calls at a sitting. Think of this process as "entertainment," be positive, and keep going until you reach your calling-number goal or you run out of energy.

Have your approach to each new prospect planned out *before* you make contact. Explain that you have been trained as a digital retoucher and restoration artist using Photoshop. (Good digital retouchers are very hard to find, whereas mediocre ones are common.) Offer to send them some literature describing your work and your price list. Take down the name of the photo studio and the individual you talked to, recording any personal or specific information that was shared.

A problem commonly encountered when making initial contact is the receptionist who feels responsible for keeping the decision-maker isolated from salespeople. It is important to treat this person with respect, and gather important information from this individual, seeking to determine who the "power person" in the business is. After establishing some rapport with the receptionist, explain that you are a professional photo retoucher, and that the owner/photographer always has a need for such services. Keep a positive perspective, reframing, if necessary, any negative responses as positives. Remember, when you visit the studio the person you are talking to will likely also be the first person you encounter when you walk in the door. Don't make assumptions about who may answer the telephone—it may be the owner, or one of the owner's family members.

Talk to the decision-maker as soon as possible. If it is impossible to speak with them at this first contact, set a telephone appointment for the near future. Confirm that you have the correct, complete address for the studio.

2. **Communicating as a Follow-Up.** If you promise to send material, be certain to send it within a week from the time of the initial call. Include an introductory cover letter, describing the services you have to offer, and a current price list (see "Developing Your Price List," on page 117), a copy of your brochure (see "Developing a Marketing Brochure," on page 117), and a coupon for one-half hour of free retouching. When doing mailings, it is handy to have a computer word-processing program with mail-merge capability to address the letters and envelopes. A positive, personal touch is to personalize the letter with the date of the phone call and the name of the person you spoke with.

3. **Completing the Follow-up Visit.** The follow-up visit should be planned within a month or two—and no more than six months—after you send out the follow-up information. Plan out your visits by mapping out the location of all studios you have contacted and plan your visit to make the most effective use of your time. Once your visiting plan is formulated, call each studio to make an appointment. Plan your visits for approximately ten minutes and maintain the plan unless invited to stay longer. It is important that you demonstrate respect for the photographer's time. Bring samples of your work with you, discuss their business needs, and review your price list—assuring them about your policies before beginning a job.

Keep the interview on a positive note, regardless of the demeanor of the photographer. If you alienate one photographer, you could easily find yourself "blackballed." If you follow this Three-Point Marketing Plan, you will soon find your business growing. Pursue this plan until all the identified potential customers in your area have been contacted.

▷ THE MOST EFFECTIVE WAY TO SELL YOUR WORK

Consider every person you meet a potential customer. This means take the opportunity to share your business with them. If such an opening does not present itself, treat them with respect and maintain a positive contact with them. Even if you never see them again, you never know who is observing you.

Be positive and enthusiastic about what you do as well as who you are. There is nothing more eye-catching than a smile. When you feel comfortable, join the local photographer's association and present yourself and your work

there. Join networking groups; arrange to provide presentations to community organizations in your area. If you are having difficulty identifying these organizations, contact your local Chamber of Commerce and they will gladly provide you with a list for a small fee.

Keep in mind that the possibilities are limitless! You are only restrained by your imagination, and any unwillingness to venture forth into the unknown to explore new territory. The more fearless you can allow yourself to be, the more effectively you can sell your services.

▷ WHERE ARE YOUR MARKETS?

There is more than enough work available for competent digital retouchers. Once you complete the Three-Point Marketing Plan, do not sit back and wait for the work to pour in—no matter how successful the response appeared to be. The effective service provider must always be selling and seeking new markets.

(*Note:* As your business expands and your work becomes known, it is not unusual to be approached by individuals who would like for you to "work your magic" with their family portraits. Remember that the professional photographer who created the original portrait holds the copyright, which is valid for fifty years. If a professional photographer is involved, it is important to work with or through him/her and not with the customer. If the photographer does not want to be involved in the process, be sure to obtain his/her written permission [a signed release is always appropriate to protect yourself legally] to alter the photograph. It is always important to contact the photographer for permission. This will not only keep you in the clear legally, but it may provide you with a positive contact [you have demonstrated your professional attitude and respect for the photographer's pro-

fessional standing!] and open the door for future work with that photographer.)

There is no reason to spend your time or energy visiting the chain photo shops, usually found in shopping malls. They usually are selling package deals for a minimum fee and either avoid retouching or complete their own. One-hour photo studios are also unproductive marketing targets. Some of the potential markets you can explore are portrait, commercial and animal photographers.

Portrait Photographers. These photographers specialize in portraits of individuals and families. Jobs from them may be a simple touch-up, or may involve more complicated processes such as adding body parts, or moving family members (including adding or removing a family member) in a portrait. These professionals may become a rich referral source, as many people bring old family photographs needing repair to photographers. It is important for you to constantly remind them of the types of work you can accomplish.

Commercial Photographers. It is fruitless to attempt to make a marketing contact with commercial photographers if you do not have personal connections with an ad agency. These are usually very closed systems, and most agencies complete their own photo manipulations in-house. If you are fortunate enough to work with a commercial photographer, and he or she is impressed with your work, this might provide an opening into an entirely new marketing area for you.

Animal Photographers. Both horse and dog photographers occasionally need an expert digital photo artist. Contact local breeding associations, dog show breeders and pedigree show ranches to inquire as to which local photographers work with their animals.

▷ PHOTO RESTORATION AD IN THE YELLOW PAGES

You may generate some business directly by running a small, one-line ad in the yellow pages under Photo Restoration. Don't make this an expensive advertisement, but include your name and telephone number.

▷ DEVELOPING A MARKETING BROCHURE

Sell the potential customer on your skill when developing a marketing brochure. If you are just starting out with limited funds, you probably cannot afford the expense of hiring a graphic designer to develop an expensive brochure for you. So, develop one for yourself. Keep the following in mind as you do:

1. Who is your prospective customer base? Will they be more responsive to something that is "wild and crazy" or to a more conservative approach?
2. What example do you have available that might best reach out and "grab" them, and yet demonstrate your expert ability.
3. Keep it simple, but creative. Use grayscale, and print it out on a quality printer.
4. Include a return address.

▷ WHAT WILL A NEWSLETTER DO FOR YOU?

A newsletter can serve as an effective communication tool and personal link between you and photographers. Allow your creativity to flow freely—you want it to capture the reader's attention. The goal is for anyone reading the newsletter to equate you with retouching. There are a number of specifics to include:

- Provide samples of your work
- Provide a copy of your price list
- Share triumphs and failures
- Inject humor whenever possible
- Explain the benefits of doing business with your service

If you have trouble writing effectively and/or creatively, seek the help of a friend. Match graphics to your stories, which you can create out of your life events. If you are persistent and get it out on a regular basis, you may discover long-term benefits accruing. Send your newsletters to your regular mailing list, and carry extra copies with you to hand out to potential customers.

▷ DEVELOPING A PRICE LIST

It is important to develop a realistic price list that will provide for your business needs while providing your potential customers with a cost incentive over what they would pay at a lab. It is important to indicate an hourly rate, but to also develop a specific task price list. Humor may help ease customer resistance. Some examples of specific tasks that I include on my price list are:

- Open eyes
- Head replacement
- Changing hairstyle
- Changing backgrounds
- Ear straightening
- Animal leg placement changes
- Animal gender alterations
- Digital 8" x 10" prints
- Writing image to CD

▶ Appendix A

Suggested Plug-Ins

Plug-ins are software extensions that are installed into Photoshop to add new or enhanced features. They are designed to enhance and expedite a number of Photoshop functions. There are several well-known products on the market.

▶ EXTENSIS

Intellihance 2.0.—Intellihance is a tool that optimizes photo images in a single step. This is accomplished by applying filters for contrast, brightness, saturation, sharpness, and despeckle. The manner in which filters are applied can be customized by choosing from predefined menus or using the Fine Tune option for user control. Preference can be saved and applied to multiple images.

Mask Pro—Mask Pro quickly creates professional quality Masks. This tool averages out a color sample, keeping or dropping colors that have been selected, until only the desired image remains. The program accurately removes all but the image that is desired to be saved, leaving the image smooth and free of jagged edges. The edges are softened, and the image is ready to be used.

Photoframe—This is one of the most powerful edge creation program. This plug-in goes beyond the ordinary, with special effects like shadows, glows and bevels with over 1000 professionally designed edges.

PhotoGraphics—Powerfully mixes illustrative effects directly into Photoshop.

Portfolio—This is one of the best investments, because it allows the user to organize images so they can be easily retrieved.

▷ TEST STRIP

Test Strip is one of the best products available at this time to assist in adjusting the color balance of your image, and it is very simple to use. This powerful color correction tool makes proofing easier, faster, and more precise. It provides a shortcut to achieve accurate color reproduction while eliminating the need for multiple color proofs. Test Strip offers full-screen previews, zooming, a Before and After comparison, precise changes, a Task List, and Test Proofs.

▷ NIK FILTERS

Nik Color Efex & Nik Color Efex Pro—These software packages are made for photographers, and offer true photographic-type filters, such as polarization filters and starlight filters.

Nik Sharpener and Sharpener Pro—This is a series of sharpening filters that make the sharp-

ening filter demonstrated in this book (Unsharp Mask) seem obsolete. The Unsharp Mask filter can deliver a great product on the screen—but in print it does not always work out. These filters are made for all types of printers: ink-jet, image-setters, and printing presses.

Type Efex—This is a series of actions that can be applied to type. It is fun and easy to use.

▷ GENUINE FRACTALS

A plug-in that allows small files to be enlarged to large file sizes with a sharp outcome. This program is a powerful interpolation program that will actually create good results if the original image is sharp.

▷ AUTO FX

Auto FX Edges: This plug-in features 10,000 edges and is the the most well known of this company's software.

Dream Suite: A visual imaging solution that works beautifully with Photoshop, if you want to take Photoshop one step further. This product can create an old-world crackle on your image and give you some very interesting options with your type.

▶ Appendix B

Resources

The following list of URLs can serve as a master list of resources available to you. This list is by no means exhaustive.

▷ ADOBE PHOTOSHOP

www.adobe.com

▷ POWERFILE FOR THE JUKEBOX

www.dvdjukebox.com

▷ WACOM TABLETS

www.wacom.com

▷ EXTENSIS PLUG-INS

www.extensis.com

▷ VIVID DETAILS

www.vividdetails.com

▷ NIK PLUG-INS

www.nikmultimedia.com

▷ AUTO FX SOFTWARE

www.autofx.com

▷ GENUINE FRACTALS

www.lizardtech.com

▷ APPLE COLOR MANAGEMENT

www.apple.com/colorsync

▷ PRINTERS

www.hp.com
www.epson.com
www.fujifilm.com
www.canon.com
www.kodak.com

▷ UV PROTECTANT SOLUTIONS

www.lacquer_mat.com
www.neschen-accutec.com

Glossary

Actions—Photoshop can record the steps to take to accomplish a task and play them back to you through the Actions selection. Once you have set them up, you can then use this feature to repeat a series of steps automatically.

anti-aliasing—A process that smooths the rough edges (or jaggies) of bitmapped graphics. This is normally accomplished by blurring the edges.

bit—The smallest piece of computer information. The computer is a binary device that uses binary numbers, 0 or 1. This term is also used with color to describe the basic units of each of the RGB colors used by the computer. Example: a 24-bit color would indicate that there are 8-bits (basic units) of color information available for each of the RGB colors.

bit depth—Also called pixel depth or color depth. As the value of the bit depth is increased, the number of colors available per pixel also increases. For example, a bit depth of one has two color values: black and white. Therefore, a one-bit image has only black and white colors, with no shades of gray.

bitmap—An image that is made up of a cluster of dots (or pixels).

burn—A darkroom term used to describe the selective darkening of an image.

byte—Eight bits. May also refer to a character on the screen.

channels—Channels are representations of each color available to you within your selected system. Depending on whether you have RGB or CMYK selected, you will have either three or four channels. If you have selected RGB, you will have three channels: red (R), green (G), and blue (B). For CMYK, you will have four channels: cyan (C), magenta (M), yellow (Y), and black (K).

clicking—Pressing and immediately releasing the mouse button. When you click on something, you position the cursor pointer over it and then click.

Clone tool—A retouching tool that enables you to select one part of the image and move it to another part of the image by copying the pixels of a selected area and placing them over the other area. Once you have selected the Clone tool, place the cursor over the area you want to select, then press Option and click. Next, move the cursor to the area the cloned pixels are to be copied onto. Single click the mouse. (This tool was called the Rubber Stamp tool in previous versions of Photoshop.)

color management—Producing a finished product with the same colors you view on your screen has been a very difficult task. Photoshop 6 has streamlined the process with a Color Management System that allows the user to calibrate both the computer and screen to provide an accurate output of colors. The process is still complicated and must be followed carefully, but it is well worth the effort to produce the desired end result. Photoshop 7 has expanded this process and honed it to a greater degree to produce even more accurate results. If you desire "perfect" results, you must invest in a colorimeter (a device that reads screen color values using a gray card).

contiguous—Associated with the Magic Wand tool, this term describes pixels of the same basic color that are not separated by other colors. When using the Magic Wand tool or the Color Range selection menu, a range (area size) can be preselected. When you click on an area with the cursor, all of the pixels in this area and within the same color range will be selected and can be pasted into a new layer to be modified.

contrast—The relationship between dark and light areas in a photograph. Contrast can be either high or low. High contrast occurs when sharp tones shift from dark to light with few middle tones. Low contrast exists when the image includes many middle tones.

cropping—Providing emphasis on the subject of the photo by trimming. Only a portion of the original photograph is used.

Despeckle—A filter that removes grain from an image.

distorting—Changing the appearance of an image by deforming or contorting the whole picture or part of the image away from its natural appearance.

dodge—This is a darkroom term used to describe selective lightening of an image.

dpi—Dots per inch. A term that measures the resolution of a printer, scanner, or monitor by referring to the number of dots in a one-inch line. This process defines how many dots of information a device can resolve in input or output. The more dots per inch, the higher the resolution.

drag—Moving the cursor while holding down the mouse button. This may be a way of moving an object, selecting an area, or moving down a menu.

duotone—When producing a grayscale image, the normal outcome is black & white with various shades of gray. Selecting a duotone output allows the user to select two inks or Pantone colors of any hue as the basis of the image.

dye-sublimation printer—Uses a color ribbon to produce the final print. This type of printer uses a printing head that heats the dyes, causing them to sublime (become gaseous) and penetrate the paper's special coating. This results in a product with greater longevity than that normally obtained from inkjet printers.

EPS (Encapsulated Postscript)—The EPS format provides a high-resolution image that may be required by some page layout programs for separations.

feather—Gradually blending an image by softening the edge.

file formats—The structure in which the data for a particular document is stored. In Photoshop there are ten different formats.

film recorders—Device that allows a digital file to be recorded on film. For high-quality images, the digital image must be scanned at a high resolution. (For example, a 35mm image would need a resolution of at least 4800dpi, whereas a 4" x 5" format image might only require 2400dpi for a high-quality output.)

gamut—The range of colors that a color system or device can display/print. (Note: The spectrum of colors that can be seen by the human eye is greater than the range that can be printed.) The RGB gamut is substantially less than the CMYK gamut.

Gaussian blur—A filter that provides a softening effect. This tool simulates a traditional darkroom process in which gauze was placed under an enlarger to soften the image, providing an even effect.

gigabyte—A measure of computer memory or disk space that's equal to 1,024 megabytes or 1,073,741,824 bytes. It is abbreviated as G, GB, or gig.

Gradient tool—A tool that provides a gradual change from one color to another in the selected area of the image. This tool can be used to create a subtle background by clicking and dragging from point A to point B (the method of defining the area to be changed, in this case).

graphics tablet—A flat, electronic unit equipped with a stylus that functions as a replacement for the mouse. This device is often used for drawing within digital imaging programs. When the stylus is touched to the tablet, the tablet conveys its position to the computer (whether it is functioning as a drawing pen or as a mouse).

grayscale—In photographic terms, a picture that contains shades of gray as well as black and white.

halftone—A method of converting an image into a pattern of small dots. The pattern of dots is described by a "line screen" with higher numbered screens resulting in better looking photos.

hard drive—The part of the computer that stores digital information, including the system software (on a Macintosh computer this indicated by an icon on the computer's desktop; on a PC, this normally refers to the C: drive). External hard drives that can be connected to a computer are also available. These devices are very helpful electronic storage devices that expand your computer's storage area without the use of removable storage devices. External hard drives are also used by some professionals for

backup storage of the computer's information. As such, they can be removed each night and stored separately from the computer.

History Brush—A tool that allows you to select a previously-created version of the image (called a history state) in the History palette, and "paint" it onto the current image.

History palette—A palette that automatically saves twenty states in its default selection. A state is created each time the mouse is clicked. These states are displayed in the History palette (Window>Show History. Once the states are displayed, they can be viewed individually by clicking on them in this palette.

ink-jet printer—A computer printer that creates a print by spraying or spattering ink onto the paper. It will print to various types of paper, including photographic-quality paper. The quality of printing and longevity of the inks may vary greatly from one printer model to another, and may depend on the manufacturer. Ink-jet printers are usually more economically priced than other printers, which makes them an attractive alternative for the price-conscious individual. However, the cost of ink and paper for photographs may be much more expensive than for other types of printers (such as the dye-sublimation printer).

jaggies—The blocky, stair-stepped look common to low-resolution bitmapped graphics.

JPEG (Joint Photographics Experts Group)—A compression format that tosses out redundant information. Data is lost. Compression can be conducted at a low level (minimal loss of data), but the higher the compression ratio the greater the loss of data, degrading the quality of the image. This format is not normally effective for creating photographic quality prints since once the data is lost, it cannot be recovered.

kilobyte—A measure of computer memory or disk space or document size that is equal to 1,024 bytes. It is abbreviated as K.

Lasso tool—A tool that allows the user to isolate part of an image and work within that area exclusively. With an area isolated, tasks such as adjusting colors, modifying shapes, etc., can be accomplished without affecting other parts of the image.

layer—A means of separating the parts of an image, or layering. A specific layer can be adjusted or deleted without impacting any other layer.

layer mask—Adds a mask (black or white) to the layer, permitting the user to edit the layer without altering the actual pixel data. The black layer mask covers the layer and can be painted on with white to reveal areas of the layer. The white layer mask reveals everything in the layer, permitting the user to paint selected areas with black to delete unwanted areas of the layer.

layer mode—Accessed via a pull-down menu at the top of the Layers palette, this option allows the user to specify how (if at all) the data on a layer interacts with the data on the layer beneath it.

Layers palette—The Layers palette preserves and displays the original image data on the background layer (also known as the foundational layer). Additional layers can be created in numerous ways. The purpose of the Layers palette is to store and display the various layers that are created. This allows the user to maintain a degree of freedom to return to various layers and either modify or blend them together in the process of modifying the image.

Magic Wand tool—This selection tool is used to instantly select all of the pixels of the same color by clicking on an area of the image that displays the selected color. Before making the selection, visit the options menu and set the tolerance (the greater the number, the more liberally Photoshop will define your color, and the more pixels it will select). You can also set the following options: Anti-Alias (softens edge of selection when checked), Contiguous (when checked, Photoshop only selects pixels within the image that are separated by another color), and Use All Layers (when checked, Photoshop will select pixels in all layers).

marquee—The series of moving dots that surround a selected area.

Marquee tool—A selection tool in the shape of either a rectangle or an oval (also called the Elliptical Marquee) depending on which setting you select. Once activated, you can click and drag the tool over an area to quickly select it.

megabyte—A measure of computer memory or disk space or application size that's equal to 1,024 K, or 1,048,576 bytes. It is abbreviated as MB or mb.

Navigator palette—A palette that displays a preview of the image you are working on. The red box within it indicates the area of the image you are working on. It is readily available at all

times. This palette also displays the percentage that the portion of the image being worked on has been magnified.

noise—A special effect provided by a software filter that adds photo paper grain or other speckled effects. Resembles the noise seen on a television set.

option bar—Lists the options available for the tool being used. This display is normally open at all times, but it can be closed. It is my recommendation that it remain open at all times. (For versions of Photoshop prior to 6.0, this same information is available within a palette that has to be deliberately opened.)

out-of-gamut—The color gamut of a device is the range of color it can reproduce. Colors that are displayed in a source device (such as a monitor) but are not reproducible in the destination device (such as a printer) are called out-of-gamut colors, and have to be replaced with some other color.

palette—A floating window within an application that is normally located above an open document permitting easy access to its contents.

pixel—The smallest element of a picture that can be controlled by the computer. The plural, pixels, is often used to describe the total number of dots that make up the entire image. "Pixel" is short for picture element (pix-el). Pixels are also often called dots.

plug-ins—Photoshop comes equipped with a plug-ins folder that contains some files that fulfill specific functions in the program. You can also add additional third-party programs (designed to work with Photoshop) into this folder to enhance the capabilities of Photoshop.

ppi (pixels per inch)—The number of pixels per inch in an image.

Quick Mask—A masking tool located in the tool bar under the Color Picker. With a selection active, clicking on the Quick Mask icon causes a red mask (the default color) to cover everything in your images except the selected area. This transparent mask then allows the user to view the underlying parts to be selected in order to make a more accurate selection. With the Quick Mask active, black acts as a paintbrush and white as an eraser as you paint on the mask.

RAM—An acronym for Random Access Memory, this is a measure of the quantity of memory available to the computer to run the programs. There is hardware available (called

memory chips) that allows the expansion of RAM. This additional memory can generally be installed by the user, and increases the computer's operating speed and program access.

resolution—The density of pixels in an image.

resolution, interpolated—A term often associated with flatbed scanners, the interpolated resolution is a figure based on the maximum resolution the scanner can provide with software enhancement of the data. Interpolation of an image only adds pixels, not photographic information, so it does not improve image sharpness. Therefore, it is a meaningless figure for scanning photographs. *See also* resolution, optical.

resolution, optical—The optical resolution of a flatbed scanner gives an accurate idea of the quality of the scanned image, because it relies on the scanner's optics without software enhancement of the data. The range of resolution represents the resolution across the bed and along the length of the scanner. The higher the optical resolution, the sharper the image of the final scanned output. *See also* resolution, interpolated.

saturation—A description of how pure a color is; the richness and brightness of a color.

scanner—A device that converts an image into a digital file that the computer can read. This device allows an image to be opened in a computer program so it can be modified and printed out in its revised form.

sepia tone—This term was originally developed to describe a chemical process used by photographers to create a brown and white image (with brown tones) rather than black and white image (with gray tones). Photoshop offers this process as an option for the final output, and also allows the user to select any number of color combinations in addition to brown and white.

shadow—The darkest part of a photograph.

sharpness—The crispness of the appearance of the image.

shift and click—To hold down the Shift key while clicking the mouse button. This process permits the selection of multiple objects.

Swatches palette—A palette that provides a variety of color samples. You can select from these using the cursor, and use them to change the color of a selected area of an image.

TIFF (Tagged Image File Format)—This has become the primary standard format that allows users to cross platform limitations. Most

other computers can open an image saved in TIFF format. TIFF permits compression without loss of image quality.

tolerance—A setting for the Magic Wand tool that allows the user to select how liberally the tool will interpret the color you select. The setting can be from 0 to 255, with the lower numbers strictly limiting the color variance and the higher levels allowing a wider range of variance.

track ball—A device used in place of a mouse. The device is stationary and contains a somewhat large ceramic or plastic ball in the center that moves the cursor as it is rotated. Buttons on either side of the ball function as a mouse key to click the cursor. This is a very effective space-saving device, because it remains stationary, unlike a mouse.

Unsharp Mask—A filter that allows the user to apply a sharpening effect to all or some of an image. This can be an effective way to sharpen an image that is mildly out of focus.

Variations—This menu option was called a ring-around in earlier versions of Photoshop. It is located under Image>Adjust>Variations. When activated, a dialogue box displays the original image along with several alternate previews of the image. By selecting from among the preview images, you can make color and saturation adjustments to the image.

vector-based type—A form of type (or text) that can be scaled without loss of clarity. Unlike pixel-based (or raster) type, which is made up of pixels and becomes blurry as it is enlarged, vector-based type is composed of mathematically-determined lines and curves that can be made as big or small as you like without losing sharpness.

Index

Other Books from
Amherst Media

Watercolor Portrait Photography
THE ART OF
POLAROID SX-70 MANIPULATION
Helen T. Boursier

Create one-of-a-kind images with this surprisingly easy artistic technique. $29.95 list, 8½x11, 128p, 200+ color photos, order no. 1698.

Basic Digital Photography
Ron Eggers

Step-by-step text and explanations teach you how to select and use all types of digital cameras. Learn all the basics with no-nonsense, easy to follow text designed to bring even true novices up to speed quickly and easily. $17.95 list, 8½x11, 80p, 40 b&w photos, order no. 1701.

Portrait Photographer's Handbook
Bill Hurter

Bill Hurter has compiled a step-by-step guide to portraiture that easily leads the reader through all phases of portrait photography. This book will be an asset to experienced photographers and beginners alike. $29.95 list, 8½x11, 128p, full color, 60 photos, order no. 1708.

Basic Scanning Guide For Photographers and Creative Types
Rob Sheppard

An easy-to-read workbook that offers practical knowledge of scanning. It also includes excellent sections on the mechanics of scanning and scanner selection. $17.95 list, 8½x11, 96p, 80 photos, order no. 1708.

Traditional Photographic Effects with Adobe Photoshop
Michelle Perkins and Paul Grant

Use Photoshop to enhance your photos with handcoloring, vignettes, soft focus and much more. Every technique contains step-by-step instructions for easy learning. $29.95 list, 8½x11, 128p, 150 photos, order no. 1721.

Digital Imaging for the Underwater Photographer
Jack and Sue Drafahl

This book will teach readers how to improve their underwater images with digital imaging techniques. This book covers all the bases—from color balancing your monitor, to scanning, to output and storage. $39.95 list, 6x9, 224p, 80 color photos, order no. 1726.

Beginner's Guide to Adobe® Photoshop®
Michelle Perkins

Learn the skills you need to effectively make your images look their best, create original artwork or add unique effects to almost image. All topics are presented in short, easy-to-digest sections that will boost confidence and ensure outstanding images. $29.95 list, 8½x11, 128p, 150 full-color photos, order no. 1732.